THE PRACTICAL ZONE SYSTEM

THE PRACTICAL ZONE SYSTEM

THIRD EDITION

CHRIS JOHNSON

Focal Press

BOSTON OXFORD AUCKLAND JOHANNESBURG MELBOURNE NEW DELHI

Focal Press is an imprint of Butterworth-Heinemann.

 A member of the Reed Elsevier group

 Butterworth-Heinemann supports the efforts of American Forests and the Global ReLeaf program in its campaign for the betterment of trees, forests, and our environment.

Cover design by Amy Evans McClure and Chris Johnson.
Photo illustrations by Chris Johnson unless otherwise indicated.
Graphic illustrations by Marty Walton and Anne Walzer.
Front cover computer graphics by Chris Johnson.

Library of Congress Cataloging-in-Publication Data
Johnson, Chris, 1948-
 The practical zone system / Chris Johnson. — 3rd ed.
 p. cm.
 Includes index.
 ISBN 0-240-80328-0 (pbk. : alk. paper)
 1. Zone system (Photography) I. Title.
TR591.J64 1999
771—dc21 98-45670
 CIP

British Library Cataloguing-in-Publication Data
A catalogue record for this book is available from the British Library.

The publisher offers special discounts on bulk orders of this book.
For information, please contact:
Manager of Special Sales
Butterworth-Heinemann
225 Wildwood Avenue
Woburn, MA 01801-2041
Tel: 781-904-2500
Fax: 781-904-2620

For information on all Butterworth-Heinemann publications available, contact our World Wide Web home page at: http://www.bh.com

10 9 8 7 6 5 4 3

Printed in the United States of America

This book is dedicated to ANSEL ADAMS.

Contents

As long as I can earn enough to pay my taxes I'll be happy. I'm not a professional photographer you know, I'm an amateur. "Amateur" is the French word for lover.

Imogen Cunningham

Preface

Much has changed in the years since 1986 when this book was first published. At that time fine art black-and-white photography and the Zone System were somewhat closer to the margins of mainstream photographic practice than they are today. One sign of the change is that all of the major manufacturers of photographic supplies have made a serious recommitment to providing serious "amateurs" with high-quality black-and-white materials. Years ago Kodak, developed its "T-Max" line of films and developers and added Elite to its list of exhibition-quality black-and-white papers. Ilford responded with Delta 400 and 100, updated its standard films to HP-5, FP-4, and Pan-F "Plus," added Ilfotec HC to its developers and greatly improved its Multigrade Fiberbase paper. As of this printing, Kodak's XTOL developer is the newest product to be seen, and there are dozens of excellent new black and-white films and papers on the market from all parts of the world. All of this is tremendously exciting to those of us who appreciate the richness and depth of fine art photography.

Digital imaging techniques and post-modern theory have begun to reshape our ideas about what photography is, as its claims to "truth" are being challenged and opportunities for qualitatively new forms of creativity are presented.

Not surprisingly, there has also been an increasing demand for clear information on how to best take advantage of these new tools.

This book is written for those of you who love the art of photography but are frustrated with the complexity of photographic technique. Typically, many of us have small darkrooms and large investments in equipment, and we have spent far too much time trying to figure out how photography works. Unfortunately, many of us are left with the lingering feeling that there may not be a simple and practical way to learn how to take technically good photographs.

Until Ansel Adams (in collaboration with Fred Archer) formulated the Zone System, a serious student had only two choices: either study sensitometry at a professional school or stumble along learning by trial and error. The Zone System has done away with all of that. Unfortunately, over the years the Zone System has gained a reputation for being complex and a waste of time. Happily this is not true. The Zone System is not only easy to learn and practical to use but also is essential for any serious photographer to understand.

After teaching hundreds of students, I can confidently say that if you have learned how to develop a roll of film, you can learn to master the Zone System.

Recognizing the ever-increasing importance of the Zone System raises two basic questions.

First, what does it take to really understand why the Zone System works? This question assumes that some degree of understanding is preferable to blindly following rules of thumb. The variety of books currently available on the Zone System take somewhat different approaches to this question. An analogy could be made to learning how to drive a car. It is perfectly reasonable to argue that one should begin driving lessons by carefully explaining in detail how internal combustion engines work, what gear ratios mean to the transmission of mechanical energy from the pistons to the wheels, and so on. This is roughly equivalent to teaching students approaching the Zone System about logarithms, characteristic curves, and sensitometry.

The problem is that after you have finished explaining these subjects in detail, what has the student really learned? Have you really completely explained the processes involved? Are there not always ever more subtle and deeper scientific questions that you have glossed over because you have decided that they are not important? There will always be people who want to know more, and at some point all educators need to draw a line at what they think students need to know before sending them off to experiment on their own.

The fact is that most people manage to drive very well after simply learning how to operate the vehicle and a reliable method for avoiding hazards. After that we develop skills in our own ways from the practical experience of getting from here to there over and over again.

My approach to writing this book has been to avoid trying to explain all of the science behind the Zone System. Instead I teach all of its basic principles and the logic of how it applies to real life.

I realize that some will find this approach not rigorous enough, but my experience, after years of teaching the Zone System to beginning students, has been that once you understand enough to begin achieving consistently good results, the confidence you will gain from that accomplish-

ment will carry you through the learning process to the level of skill you need for your work.

There are a number of excellent, more detailed technical books on the Zone System that should be read by those who favor a scientific approach to their work, and some of them are listed in Appendix L.

The second question this book addresses is, What information do you really need in order to apply the Zone System to your own photographic problems?

The answers to this question are contained in Chapter 9, "Zone System Testing: Method 2." Here you will find the results of tests that I and my friends conducted on ten different films in ten different developers. These tests, which made use of all of the major products including XTOL and Ilford's Ilfotec HC, were conducted under actual shooting conditions. We then spent time field testing these results in a working photolab and with my students at the California College of Arts and Crafts to assure their accuracy. Appendix A contains comprehensive descriptions of the characteristics and uses of all of these products.

My hope is that by updating and expanding this information, and adding discussion on subjects such as digital photography and printing controls, this book can remain a truly practical guide to the Zone System.

As you begin this text, keep in mind that the Zone System is not intended to be an end in itself, any more than is the study of medicine. Learning any new technique necessarily involves an ordering and restructuring of the way that you perceive the world. The beauty and the real value of the Zone System unfolds in the practice of actually using it to create meaningful images. The problem is trying to create with no system at all. As you begin to use the Zone System you will find yourself modifying and adapting it to best serve your own needs. As this happens the Zone System will become less formal and more a natural part of your creative life.

For those who are just beginning photography, I'd suggest that you start by reading "A Primer on Basic Photography" at the end of this book. The primer will acquaint you with most of the language of basic photography and will generally make it easier for you to understand some of the new concepts that you will learn.

> **Note:** Readers familiar with other writing on this subject know that the terms "previsualization" and "visualization" are both used among Zone System speakers to describe the act of mentally picturing the photographic subject as the finished print. Also, the words "contraction" and "compaction" are both used to describe the process of reducing negative contrast. After much thought, and because Ansel Adams used these words, I have decided to use the terms "previsualization" and "contraction" throughout this book.

Before you begin, consider this: In spite of the high cost of photographic materials, film, chemistry, and paper are cheap when compared to the satisfaction you will get from producing a truly fine image. If it is at all possible, don't skimp! If your goal requires an extra roll of film, or more time and effort, you will see that it is worth it.

Beyond that, my motto these days has become:

Show up.
Pay attention.
Tell the truth.

Acknowledgments

This book could never have been completed without the advice, generosity, and support of my friends and students. I would like especially to thank Steve Dunham for helping to formulate the basic approach presented here.

I am deeply grateful to the following people for their important contributions: Sandi Anderson, Chris Boehnke, Tim Bruno, Dea Cioflica, Susan Ciriclio, Judy Dater, Iris C. Davis, Amy Evans McClure, Kevin E. Graham of Ilford's Imaging Products Division, Charlene Harrington, Sharon Madden-Harkness, Don Hilliker of Kodak's Professional Imaging Division, Justin McFarr, Jim Jordan, Malcom Kwan, Robert Bruce Langham III, Julio Mitchel, Margaretta Mitchell and Frederick Mitchell, Selene Miller, June Moss, Anne Nadler, Fred Rohe, Julia Rowe, Frank Schultz, Jean Schultz, Bob Semenak of Robyn Color Lab, Ben Shaykin, Will Van Overbeek, Laura Walton, Marty Walton, Anne Walzer, Ben Yerger, Richard Zakia, and Lagrima de la Luna Zegarra.

I would also like to again thank Arlyn Powell and David Guenette for their patience and support in the publication of this book's first edition.

CHAPTER 1

"Will It Come Out?"

During a portion of a fourteen years experience as an amateur photographer, I always supposed that a good judgment, combined with experience (the latter implying the generous use of time and plates), would eventually enable me to obtain a good negative every time I exposed a plate. . . . That was my greatest mistake.

Reprinted from "My Greatest Mistake,"
by William Bullock, Bulb and Button Magazine, *Sept. 1900*

AN INTRODUCTION

The loneliest people in the world are probably photographers in darkrooms waiting to see if their negatives will turn out the way they want them to. Add to this the frustration of trying to make a fine print from a bad negative, and it is easy to see why uncertainty about photographic technique can be a major stumbling block to beginning photographers. This also explains the proliferation of automatic cameras, which are fine for casual use, but are too limited for serious, creative work. What every photographer needs is a clear, direct working method that produces predictable results. The Zone System is specifically designed to do just that. When used properly, it will allow you to deal confidently with any exposure or development problem you are likely to encounter.

Anyone familiar with the work of Ansel Adams or Minor White knows how powerful a creative tool the Zone System can be. The problem has been finding a way of making the Zone System understandable to photographers who are not technically inclined.

The irony is that in practice, the Zone System is remarkably easy to use. I discovered this after spending almost two years poring over the available literature and experimenting with homemade densitometers.

1

Somewhere along the way, I developed a personal way of working that was pure Zone System but bore little relation to the Herculean effort required to learn it.

When I began teaching photography, I quickly discovered that if I taught my students what I did in the field, instead of boring them with the complicated details of why it worked, it was as easy for them to learn the Zone System as it was for me to use it. In other words, it is not the system itself that confuses people, but rather the highly technical details some people use to explain it.

The Zone System can give you a completely new way of photographically seeing the world around you. When you begin using it, the path between what you see in front of the camera and what you get in your prints becomes very clear and direct.

Let's consider a number of questions that beginning students usually ask.

Q: What is the Zone System?
A: Basically there are two technical problems that frustrate serious photographers. The first problem is how to give your film the proper amount of exposure. It is very difficult to make a fine print from a negative that is seriously under- or overexposed. So-called "averaging" methods of exposure are unreliable, and bracketing cannot assure you of correctly exposing any given frame of your roll. The Zone System teaches you a simple way of using any reflected light meter to achieve exactly the exposure you want every time.

The second problem is how to produce printable negatives from scenes that have either too much contrast or not enough. The processing instructions provided by film and chemistry manufacturers are not adequate for dealing with the variety of lighting situations facing photographers in the real world. The Zone System solves this problem by teaching you how to control the contrast of your negatives by *systematically adjusting the amount of time you develop your film.* In essence, you will learn that film **exposure** and **development** are the only variables that you need to control to produce consistently printable negatives.

If all the Zone System did was to allow you to record a variety of photographic subjects consistently and accurately, that would be a real advantage to many photographers. On the other hand, we would all be transformed into sophisticated automatic cameras. In fact, through a key element of the Zone System known as **Previsualization**, the Zone System functions as a powerful creative tool that allows photographers a remarkable degree of creative flexibility and control over the photographic process.

A good analogy can be made between the Zone System and music theory. Music is a logical organization of raw sound that allows coherent melodies to be created and recorded. The Zone System is a functional codification of the science of sensitometry (the study of the way light and photosensitive materials interact) into a simple and manageable working method. Just as a musician who can read music is able to play any annotated score, be it jazz or classical, the Zone System allows photographers to interpret what they see in any number of creative ways.

Q: Why is photographic technique so important?
A: Ideally, there is some feeling, concept, or idea that you are trying to convey in your photographs. I think it is safe to say that the more effectively you are able to put your feelings on paper, the better your photographs will be. It is not possible to come up with a more precise definition of a "good photograph" because the range of creative possibilities is almost infinite. And yet there is a relationship between the *structure* of your photographs (print quality, composition, etc.) and their *content.* In other words, your technique has a lot to do with how well your photographs get your message across.

The balance between structure and content in art is an important measure of mature work. Too much emphasis on one or the other will weaken the overall impact of your images. Sloppy or careless technique is distracting to the viewer, and yet overly structured photographs are often stiff and boring. The goal of a student should be to master the technical aspects of the medium so that he or she can easily give their work the structure it needs to be effective, without that effort being an impediment to free expression. The Zone System is specifically designed to give photographers that freedom and control.

Q: If the Zone System is so important, how were good photographs taken without it?
A: By necessity, early photographers became masters of estimating light values and developing by inspection (see Appendix J). If there was any doubt about the exposure, they could always bracket just to be safe.

As you will learn, standardized methods of exposure and development simply are not reliable. Photographers need a way to adapt their techniques to suit the variety of problems they are likely to encounter. Many experienced photographers have developed personal working methods that are essentially derivatives of the Zone System adapted to their style of shooting. The advantage of learning the system from the beginning is that it will save you a great deal of time, money, and frustration.

Q: Isn't the Zone System useful only with view cameras?
A: No. With a view camera, each frame is exposed and developed individually. As you will see, this makes applying the Zone System to large-format photography very simple. On the other hand, the principles that govern the Zone System apply as much to roll film as they do to sheet film. Compromises are often necessary when using the Zone System with 35mm cameras, but understanding the principles involved will give you all the control you need to get consistent results.

Q: Do I need a spot meter to use the Zone System?
A: No, although spot meters are generally more accurate than wide-angle meters, and they make choosing the correct exposure surprisingly easy.

Q: Camera manufacturers give the impression that taking good pictures can be simple and automatic. Is the Zone System outdated?
A: The suggestion that any given camera or meter can solve all your photographic problems is designed to inspire confidence and increase sales. Under average conditions, any good automatic camera can give you adequate results. Unfortunately, camera manufacturers cannot anticipate the variety of lighting problems that even a casual photographer routinely encounters. For this reason, automatic cameras, even when used properly, produce disappointing results much of the time. This explains the popularity of so-called "no-fault" picture-return policies. These promotions are fair, but they are little consolation if the ruined snapshot is your last and only portrait of your beloved Aunt Penny.

Also, keep in mind that it is impossible to design a camera that will adapt automatically to the departures from the norm that are so important to creative photography. The essence of art is learning how to break aesthetic rules in coherent and effective ways. To depart from average results, it is important to understand the nature of the problems you are likely to encounter. The Zone System will provide you with a working method that is flexible enough to deal with these problems and give you creative control over the medium.

Q: How does the Zone System apply to the use of an electronic flash?
A: The Zone System is primarily designed as an aid to previsualizing, measuring, and compensating for the unpredictable contrast of natural lighting situations. With typical on-camera electronic flash units you are providing a known quantity of light to your subject, essentially eliminating the need for routine exposure calculations and contrast measurement.

For a more detailed description on the use of electronic flash, see page 78.

> **Note:** With modern electronic flash units, the exposure is determined by a thyristor circuit that controls the output of the flash. Dedicated flash units automatically adjust both the f/stop and shutter speed of the camera.

Q: Can the Zone System be used with color film?
A: The answer again is yes and no. Three interlocking elements make the Zone System work.

1. The Zone System enables photographers to visualize their subjects as finished photographic prints. Essentially, this means knowing what results you are working toward before you begin shooting. This is a valuable skill for all photographers to learn regardless of the kind of film they shoot.

2. The Zone System teaches you how to choose the correct exposure for any given shooting situation. This is especially important for color photographers because color-slide films are notoriously intolerant of under- or overexposure. Color negatives will tolerate a small amount of overexposure but no underexposure.

3. Photographers using the Zone System learn how to measure the range of contrast of their subjects and then how to select the appropriate development time to produce printable negatives. Being able to measure subject contrast accurately is especially important for color photographers because color films (in particular color-slide films) are more limited in the range of contrast they can register than are black-and-white films. Because color films must be developed within narrow predetermined limits of time, the ability to visualize, measure contrast, and choose accurate exposures is crucial for working with color materials.

For more information on color films and the Zone System see page 74.

CHAPTER 2

Print Quality and
Negative Contrast

Let's begin by defining a few important terms. Throughout this book you will find that the word **contrast** has different meanings depending on whether I am referring to the contrast of the *subject* you are photographing or the *negative* that you will use to make the print. In general, the word "contrast" refers to the relative difference between dark and light areas of the subject or negative.

SUBJECT CONTRAST refers to the difference between the amounts of light being reflected by the darker, or "shadow," areas of the scene and the lighter, or "highlight," areas (a dark door as opposed to a white wall, for example).

> **Note:** In the Zone System, the words "shadow" and "highlight" are often used as general terms to describe any darker or lighter areas of the scene. Areas of the scene that reflect more or less light are also called "values." Thus a white wall is said to be a "highlight value," and a dark wall could be called a "shadow value." These terms will become more familiar as we go along.

NEGATIVE CONTRAST refers to the relative difference between the more transparent areas of the negative and those that are more opaque. Because photographic negatives are actually coated with extremely thin layers of silver, they are said to have *shadow densities* and *highlight densities.** The shadow densities are more transparent and correspond to the darker parts of the print.

* These densities can be measured with an instrument called a densitometer.

The highlight densities are more dense and appear as the lighter areas of the print. If any of this is unclear, refer to the "Photographic Emulsions" section of the primer (page 167) before going on.

The contrast of photographic subjects can vary a great deal from one picture to another. On clear, sunny days the contrast can be great; on cloudy days it can be relatively flat. The contrast of a given scene depends on how light or dark the objects in the picture are when compared to each other and on how much light is falling on them. It is important to learn to adapt your shooting and film-developing methods to suit a variety of different lighting situations. Modern photographic films and papers produce unsatisfactory results when the contrast of the scene is either too great or too little. If the contrast of photographic subjects never changed, as in a studio where the lighting can be controlled, it would be easy to adopt a standard shooting and processing method that would give you good results every time. Because the contrast of scenes can differ greatly, it is necessary to learn first how to measure subject contrast and then how to compensate for it.

In natural lighting situations, you seldom have much control over the contrast of your subject. As a result, the contrast of your negatives becomes the all-important factor for obtaining good prints. Until you learn how to control the contrast of your negatives, you will find that when the contrast of your subject is too great, you will tend to make contrasty negatives. When there is not enough contrast in your scene, you will tend to make very flat negatives. Needless to say, it is difficult to make a fine print from a negative with either too much contrast or not enough. When the contrast of your subject happens to be average, you will end up with that occasional easy-to-print negative and a beautiful print.

The relationship between negative contrast and print quality is very important. All too often we take the quality of our negatives for granted. Many students assume that poor print quality is entirely the result of poor printing technique. This is seldom the case. The fact is that it takes an excellent printer to make a decent print from a bad negative, but even an average printer can make a good print from a negative that has been properly exposed and developed.

The goal is to learn how to make the "perfect negative," one whose contrast allows you to print it easily regardless of how contrasty or flat the original scene happened to be.

Let's consider the four basic problems encountered when trying to make a good print from a negative that has been improperly exposed and developed.

Underexposure

The simplest way to define a "good exposure" is to say that it means choosing a combination of f/stop and shutter speed that will allow the right amount of light to expose the film. It is important to understand that if the film receives **less** than this optimum amount of exposure, the negative will be **too thin** in the areas that correspond to the darker parts of the subject. Of course, underexposure will cause the entire negative to be less dense than normal, **but the lack of density in the shadow areas of the negative is critical.** When a negative receives too little exposure, it will be transparent in areas that should print with full texture and detail (dark hair and fabric, for example). Because the necessary detail is not in the negative, these areas print as black, empty spaces.

Figure 1: An example of a print made from an underexposed negative.

Deliberate underexposure can often be used to create striking effects, but in general, these unnaturally dark areas are distracting and spoil the quality of your image. Of course, any dark area of a print can be made lighter by dodging when you make a print, **but no amount of careful printing can give a print detail that does not exist in the negative.** For this reason, avoiding underexposure is essential. The rule is: **A negative has to receive at least enough exposure to ensure that the important darker areas of the print appear realistically well lit and detailed.**

Overexposure

Overexposure results in negatives that are too dense in the important shadow areas of the print. Prints made from negatives that are overexposed will be gray and lack richness and depth.

Figure 2: An example of a print made from an overexposed negative.

Underdevelopment

Film development has its main effect on the denser or **"highlight"** **areas** of the negative. An underdeveloped negative will be too thin in these areas, and the resulting print generally will be too dark, with no sense of light or brilliance.

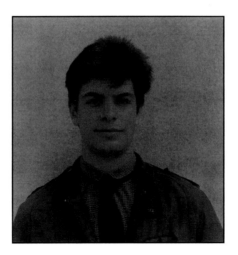

Figure 3: An example of a print made from an underdeveloped negative.

Overdevelopment

If a negative is overdeveloped, either from being developed for too long or in a developing solution that was too concentrated or too hot, or from being agitated too aggressivelyh, the highlight areas will be too dense. Because these densities are relatively opaque, the corresponding light areas of the print will be too white or "blocked up." Burning in these areas when you make a print will make them darker, but it cannot replace the lost texture and detail.

Figure 4: An example of a print made from an overdeveloped negative.

It should be noted that overdevelopment has something important in common with underexposure: they are both negative problems that cannot be corrected after the negative has been processed.

A print from a properly exposed and developed negative will have rich, detailed shadow areas and brilliant, textured whites.

Figure 5: *An example of a print made from a properly exposed and developed negative.*

SUMMARY

1. Learning how to control the contrast of your negatives is necessary because of the range of **subject contrasts** photographers have to cope with. Until you learn how to adapt your methods of **exposure** and **development** to suit a variety of lighting situations, you will only produce easily printable negatives when the contrast of your subject happens to be average. Understanding this fact is the first key to becoming a better photographer.

2. **Exposure** has its primary effect on the **shadow densities** of the negative. Film **development** primarily affects the **highlight densities**.

3. Any combination of over- or underexposure or development will result in a negative that is either too dense or too thin. It is especially important to learn how to avoid underexposure and overdevelopment because these damage your negative quality in ways that cannot be compensated for when you make a print. Underexposure permanently obliterates necessary detail in the negative's shadow areas. Overdevelopment destroys detail in the highlight areas of the negative.

Trying to make a fine print from a negative with contrast problems can be a costly and frustrating ordeal. To a certain extent, graded or variable contrast papers can help, but **learning to control the contrast of the negative itself through proper exposure and development is the secret to consistently better results.**

Now that we have defined the problems, let's begin to approach the solution.

CHAPTER 3

The Control of Negative Contrast

There is a time-honored rule that summarizes the key to consistently better negative quality: **Expose for the shadows and develop for the highlights.** What this means is that exposure and development can each *independently* control a different aspect of the negative's contrast. Let's look at this process in detail.

Expose for the Shadows

Your choice of exposure for a given negative (the f/stop and shutter speed that you decide to use) should be based on the amount of detail you want in the darker areas of your finished print. If you want the shadow areas of your print to appear well lit and detailed, give the film *more* exposure. If you want the shadow areas to be darker and less detailed, give the film *less* exposure. As we discussed in Chapter 2, a mistake at this point can ruin your chances of ending up with a satisfactory image. **Remember that exposure has its main effect on the density of the negative's shadow areas.** Under- or overexposing can ruin an otherwise beautiful print. Once you release the shutter, the fate of the shadow densities is sealed!

Develop for the Highlights

The amount of time that you develop your film will determine the density of the negative's highlight areas and its overall contrast. Just as exposure has its main effect on the shadow areas of the negative, **the film's development time will determine how white or gray the lighter areas of the print will eventually be.** If you inadvertently over- or underdevelop your film, the highlight densities will be difficult or impossible to print well.

If exposure and development did not act independently on the density of different parts of the negative, you would have no way of controlling its contrast. Knowing that exposure determines the shadow density and that development controls the highlights, you can use these two factors to your advantage. Understanding this relationship makes it easy for a photographer with a trained eye to diagnose problem negatives. If parts of the negative that correspond to the darker areas of the subject are too thin or transparent, the negative is obviously *underexposed*. If the highlight areas of the negative are opaque, the negative is *overdeveloped*. Before you go on, try the following exercise.

Underexposure

1. Gather an assortment of your problem and successful prints and their negatives.
2. Look carefully at those prints that are either too dark with empty, flat shadow areas or too gray with no black values at all.
3. On a light box (or through a window), compare the negatives from these prints with those from prints that have fully detailed, realistic shadow values. What you will see is that the shadow areas of the underexposed negatives are *more transparent* than the shadow areas of well-exposed negatives. More exposure would have solved the problem. You now know what an underexposed negative looks like.

Overdevelopment

4. Look at those prints that are too contrasty with empty, glaring white areas.
5. When you compare the negatives of these prints with negatives from prints that have well-detailed highlight areas, you will see that the overdeveloped negatives are too dense or opaque.

Overexposed or underdeveloped negatives are slightly more difficult to read, but the principle is the same.

The reason exposure and development affect the film in different ways is a function of the way film responds to different amounts of development. Figure 6 illustrates how this works.

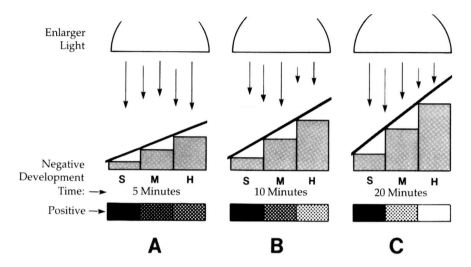

Figure 6: *The effect of increased development on the shadow (S), middle (M), and highlight (H) densities of a negative.*

Imagine that Figure 6A is a negative developed for five minutes and being viewed edge-on with greatly exaggerated shadow, middle, and highlight densities. The diagonal line illustrates the negative's contrast. The steeper the line, the more contrasty the negative. Figure 6B is the same negative after being developed for ten minutes. Figure 6C is the same negative after twenty minutes of development.

Notice that after five minutes' worth of development, all the densities have reached a given level, and the contrast is relatively flat. After ten minutes, the density of the middle and highlight areas have increased greatly, but the shadows have hardly moved at all. **Because the middle and highlight densities increase at a much faster rate as the negative continues to develop, the overall contrast of the negative becomes much greater.** After twenty minutes of development, the highlights are much denser, but again, because the shadows have remained relatively stable, the contrast of the negative is increased. This difference in the rate of density increase between the shadow and the highlight areas is a very convenient effect. If the shadow densities increased at the same rate as the highlights, the negative would simply become more dense without any increase in its overall contrast.

The point to remember is that increasing or decreasing the negative's development time does not affect the shadow densities nearly as much as it does the highlights. **This means that by varying the amount of time you develop the film, you can produce a usable negative regardless of how contrasty or flat the subject of your photograph may be.**

The general rules for controlling the contrast of negatives are as follows:

1. Your exposure should be based on the amount of detail you want to have in the darker areas of your finished print. Once the exposure is made, the shadow densities are established.

Figure 7: Shadow density is determined by exposure.

2. If the contrast of your subject is very flat, you can **simply increase the negative's development time to make the highlight densities more dense** and therefore the lighter areas of the resulting print whiter.

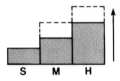

Figure 8: A longer development time increases the negative contrast of a flat subject.

3. If the subject is extremely contrasty (for example, dark foliage and bright snow in the same picture), you can compensate for this by giving the film less development.

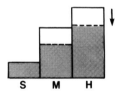

Figure 9: A shorter development time decreases the negative contrast of a contrasty subject.

In short, **expose for the shadows and develop for the highlights.**

To understand some of the implications of this rule, study the following discussion of development very carefully.

Normal Development

For every combination of film and developer, there is a certain development time that will produce negative contrast that is **equal to the contrast of the scene that you are photographing.** This is called **Normal Development**, symbolized by the letter **N**. If, for example, eleven minutes is the Normal Development Time for your favorite film and developer, that will be true as long as you continue to use that combination and do not change any of the other variables that affect development time. These variables are dilution, temperature, and the rate of agitation.

> **Note:** Paper grade 2, or variable contrast filter 2, is usually considered the standard for Normal contrast negatives. You can determine the exact time for Normal Development by testing your film as outlined in Chapter 8.

Since by definition, Normal Development means negative contrast will be equal to subject contrast, if the subject you are photographing has too much contrast, using Normal Development (eleven minutes in this example) will result in an equally contrasty negative. If the contrast of the subject is too low, Normal Development will give you a flat negative. If, on the other hand, the contrast of the subject is average, Normal Development will result in a printable negative.

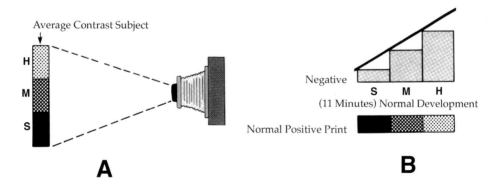

Figure 10: The effect of Normal Development on a subject with Normal contrast.

Figure 10A illustrates a negative being exposed to a subject with Normal contrast. Figure 10B shows that when the negative is given Normal Development, the resulting print will also have Normal contrast.

Normal Minus Development

If the contrast of the scene you are photographing is too great (if, for example, you are shooting in a dark room with a sunlit window in the picture), you can compensate for that problem in the following way.

First, as always, choose an exposure based on the amount of detail you want in the darker areas of the final print. **Expose for the shadows.**

Second, use a development time that is less than your established Normal Development Time to reduce the density of the negative's highlight areas.

Remember that increasing or decreasing the time that you develop your negatives will always have the greatest effect on the highlight densities. Because the shadow densities respond much less to reductions in the development time, only the highlight densities of the negative will be significantly reduced. The resulting negative will have much less contrast than the original subject and thus will print as if the contrast of the subject had been within normal limits. This effect is called **Normal Minus Development**, or **Contraction**. The symbol for Normal Minus Development is **N-**.

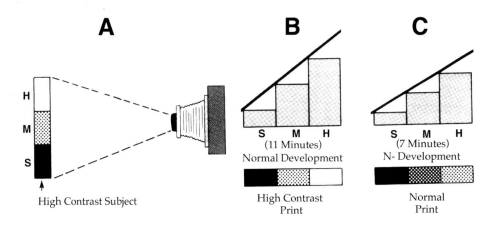

Figure 11: The effect of Normal and Normal Minus Development on an overly contrasty subject.

Figure 11A shows a negative being exposed to a very contrasty subject. Figure 11B illustrates that Normal Development results in a negative with overly dense highlights. Figure 11C shows that Normal Minus Development **reduces the density of the negative's highlight areas.** The result is a print with Normal contrast and detailed highlights.

Normal Plus Development

If the contrast of the subject you are photographing is *too flat*, for example, a dark interior or a cloudy day, you should still expose for the shadows, but in this case, you should also increase the development time (above Normal Development) to *increase* the density of the negative's highlights. This effect is called **Expansion,** or **Normal Plus Development**, symbolized by **N +**. The resulting negative will have much more contrast than the original subject and will print as if the contrast of the scene were greater than it actually was.

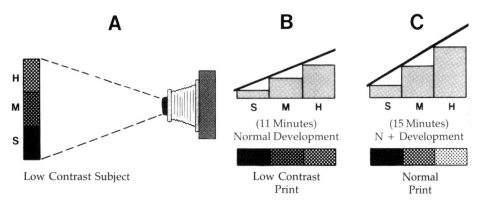

Figure 12: The effect of Normal and Normal Plus Development on a low-contrast subject.

Figure 12A shows a negative being exposed to a very low contrast subject. Figure 12B illustrates that Normal Development results in a flat, low-contrast negative and print. Figure 12C shows that Normal Plus Development increases the density of the negative's highlight areas. The resulting print has Normal contrast.

> **Note:** Increasing the negative's development time will result in more apparent grain. For this reason, roll-film photographers should try to avoid long Normal Plus Development times whenever possible.

SUMMARY

In this chapter, we have learned two very important things about how to produce consistently printable negatives. The key to fine printing is controlling the contrast of the negative to compensate for variations in the contrast of the subjects you photograph. Remember that **expose for the shadows and develop for the highlights** means choosing an exposure based on the amount of detail you want in the darker or shadow areas of your final print, then increasing your development time above Normal if the subject has less than Normal contrast or decreasing your development time (below Normal Development) if the contrast of the subject is too great.

Three general approaches to film development make this control possible.

1. **Normal Development (N)** is the standard development time for your favorite combination of film and developer that will always give you negative contrast equal to the contrast of your subject. Normal Development is the correct development time for subjects with average contrast and is determined by testing. See Chapter 8.
2. **Normal Minus Development (N-)**, or **Contraction**, is the reduction of your development time (below Normal Development) to compensate for subjects with contrast above Normal.
3. **Normal Plus Development (N +)**, or **Expansion**, is a longer than Normal Development Time to compensate for low-contrast subjects.

Thus far I have used the terms "high," "low," and "Normal" contrast very loosely. It is not difficult to visualize the difference in contrast between a bright, high-contrast situation and a flat, gray scene. To determine which of the above development procedures is appropriate, you need a way to measure the contrast of the scenes you wish to photograph. The visual concept that makes this possible is called the **Zone**.

CHAPTER 4
The Zone

The key element of the Zone System is a "visual ruler" that allows photographers to visualize and actually measure the difference between normal-, low-, and high-contrast subjects. This is called the **Zone Scale**.

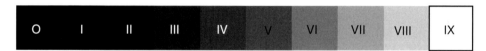

Figure 13: *The Zone Scale.*

Ideally, the tonal values in a photograph should logically represent the light and dark values we see in the world around us. When we photograph a dark wooden wall, for example, our expectation is that the print will have the tonality and detail of dark wood. The visual unit that makes it possible for us to establish this connection between the real and the photographed world is called the **Zone**.

A Zone can be defined in three simple ways:

1. **Print Values**. Each zone symbolizes a different range of dark, gray, or light tones in a finished print. For example, Zone 0 is black, Zone V is middle gray, and Zone IX is white.
2. **Texture and Detail.** Every zone reveals a different amount of texture and detail. This allows zones to be associated with actual objects that typically appear as certain zones. For example, in a normal black-and-white print, dark hair is usually Zone III, and snow can be printed as Zone VIII.
3. **Photographic Measurement.** Zones can be measured in terms of f/stops, shutter speeds, and meter numbers.

PRINT VALUES

The first definition of a zone is easy to understand if you look at the tonal values of a normal black-and-white print. In this case, the term "normal" defines a print that is realistic and has a full range of tonal values from black to white. If you look closely, you will see that almost any photograph has within it the total range of possible print tones, from the blackest black that the paper can produce to the whitest white.

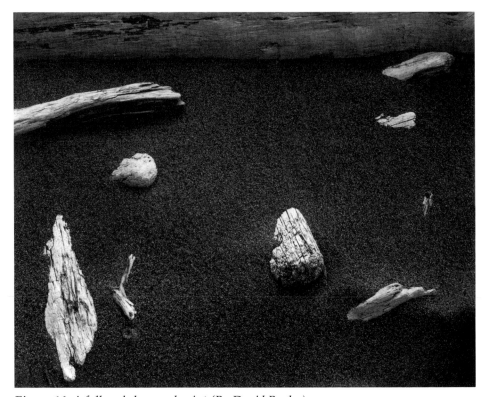

Figure 14: A full-scaled normal print.(By David Bayles)

To begin the process of associating photographic print values with the Zone Scale, imagine the total range of tones in the above photograph spread out in a continuous spectrum of gray that gradually lightens from pure black at one end to pure white at the other.

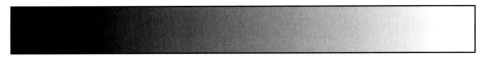

Figure 15

Any photograph has an infinite number of shades of gray. You could, for example, divide the spectrum in Figure 15 into any number of sections, and each one would be a little lighter than the one on its left. See Figure 16 for example.

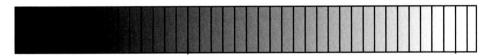

Figure 16

The Zone System divides this spectrum into ten equal parts as shown in Figure 17. At one end is a section that is completely black and at the other end a section that is totally white. Keep in mind that all the tonal values in each section can be related to some part of the print in Figure 14.

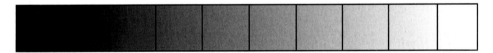

Figure 17

At this point, the scale is still continuous, meaning that each section is a "mini-spectrum" that is slightly darker at one end than it is at the other. (See Figure 18.)

Figure 18

To transform these sections into zones, we simply blend all the tonal values in each section into **one average tone that will represent all the values in that section of the scale.** It is much easier to visualize one shade of gray than a "minispectrum," *but it is important to keep in mind that each zone actually represents a small range of slightly different tones.* The scale is now divided into ten distinct steps, from black to white. If you assign a Roman numeral to each step, starting with 0 for the black section to IX for the white one, the steps are now officially **Zones.**

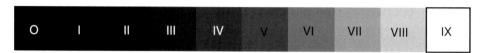

Figure 19: The Zone Scale.

The two key elements of the first definition of a Zone are:

1. Each zone is one symbolic tone that represents the range of tonal values in its section of the Zone Scale.
2. Each zone can be related to the values in any photograph. The blackest black in a print would be Zone I, and the whitest white would be Zone IX. The clear film base of the negative is Zone 0.

By definition, the Zone Scale encompasses every possible tonal value in any photograph.

Of course, the tones in any photograph can be related directly to the values of the photographic subject. Identifying a wall *in a photograph* as Zone IV is another way of saying that the wall *itself* is Zone IV. This line of reasoning leads to the second definition of a Zone: Zones as texture and detail.

My goal is to make it possible for you to look at any photographic subject and say, "In the finished print, I want that tree to be Zone III and the sky to be Zone VI." If you were confident that this could be done consistently, photography would become as straightforward a process as a painter deciding that a tree on his or her canvas should be a given shade of brown. This is what the Zone System is designed to do.

TEXTURE AND DETAIL

To relate zones more closely to the real world, I will define each zone in terms of the way it should look in a normal print. As much as possible, I will refer to familiar objects that typically appear in photographs as certain zones. These descriptions will help you visualize zones for later use. Of course, you will not always want a given object to appear as a given zone. For example, in one portrait you may want brown hair to be Zone III and in another Zone IV. Keep in mind that offset reproductions can only approximate the tonality of real photographic prints.

THE ZONES

ZONE 0 is the easiest to define. It is the blackest black that the photographic paper can produce. Zone 0 has no texture or detail and appears as the most transparent areas of the negative. Because of the slight color added to the film base by the manufacturer to prevent halation and the chemical fog resulting from development, this density is sometimes referred to as "film base plus fog."

ZONE I is also completely without texture and detail. A glance around you will reveal many areas that should be printed as Zone I, including dark recesses or tiny cracks. In a normal print, Zone I would appear to be as black as Zone 0 until you put them side by side.

ZONE II is slightly textured black. This is the first zone in which you can begin to detect a trace of texture and detail. Black cloth and very dark shadows are usually Zone II.

ZONE III is extremely important for many reasons, as you will see later. The best way to distinguish between Zone II and Zone III is to remember that while texture and detail are only *barely visible* in a Zone II area of the print, Zone III is always **fully textured and detailed**. Dark foliage, brown hair, and blue jeans are usually perfect Zone III subjects.

> **Note:** A common mistake is to consider the darkest shadow you can find in the subject as Zone III. Actually, the darkest shadows in a scene obscure most of the detail in that area. Very dark shadows are generally Zone II. Remember that Zone III is the first dark zone that is fully textured. For this reason, we define Zone III as the zone for Important Shadow Areas. (See the glossary on page 184.)

ZONE IV is best described as dark gray with full texture. When you are photographing people with dark or deeply tanned skin, it is safe to say that their skin should appear in the print as Zone IV. Of course, a variety of complexions are common to dark-skinned people, but generally they fall within Zone IV. Shadows falling on a dark person's skin would be Zone III, and the lighter areas would be Zone V.

ZONE V is fully textured middle gray, or 18 percent gray. Like most things that are average, Zone V is difficult to describe. A dark blue sky will usually print as Zone V, as will stone in normal light or weathered wood. Kodak manufactures a Neutral Gray Card for use as an exposure guide. We will discuss how this card is used later.

ZONE VI is fully textured and easy to describe because you can again relate it to skin tone. Caucasian skin that is not overly tanned usually prints as Zone VI. Shadowed white skin would be Zone V, and the highlights would be Zone VII.

ZONE VII is light gray and fully textured. Sunlit concrete and light clothing are normally printed as Zone VII. Zone VII is textured as is Zone III, but on the light end of the scale. Just as Zone III is the first zone that is fully textured and detailed, Zone VII is the last. For this reason, Zone VII is defined as the proper zone for Important Highlight Areas. (See also page 47 and the glossary on page 184 for a definition.) Beyond Zone VII, the remaining zones become progressively less detailed.

ZONE VIII is textured white. Objects such as paper, snow, and painted white walls are often printed as Zone VIII.

ZONE IX is pure untextured white. This is the zone for specular reflections or light sources. The whitest white that the photographic paper can produce is Zone IX.

Our zones are now much closer to resembling the world as we see it, with various amounts of texture and detail in areas that are darker and lighter. The computer-generated "Zone Globe" icon on the cover represents the way the Zone System conceptually moves from a continuious tone gradation on the edges, through a set of progressively darker mini spectrums, to a textured Zone Scale in the center.

At this point, you should be looking around trying to see the various zones in subjects you may want to photograph. Begin by asking yourself questions such as "In a print, would that wall be Zone IV or Zone V?" To simplify the process of seeing the real world in terms of zones, think of the Zone Scale as being divided into the three distinct sections shown in Figure 20.

The Black Zones	The Textured Zones	The White Zones

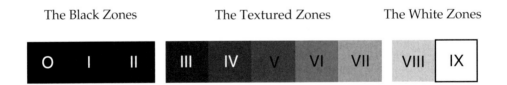

Figure 20

Any well-lit or textured surface should fall in the **textured** range of zones. In fact, you will find that most areas of any normal print are made up of these five textured zones. If the object you are considering is dark and textured, you will want it to print as Zone III or Zone IV. If it is light and textured, such as concrete or light clothing, it must be either Zone VI or Zone VII.

This same line of reasoning can help you easily identify all the other zones. If an area of the subject is black, it will be Zone I or II, depending on the amount of detail that is visible. If the subject is white and slightly textured (snow or paper, for instance), it will realistically print as Zone VIII. Zone 0 is pure black, and Zone IX is pure white.

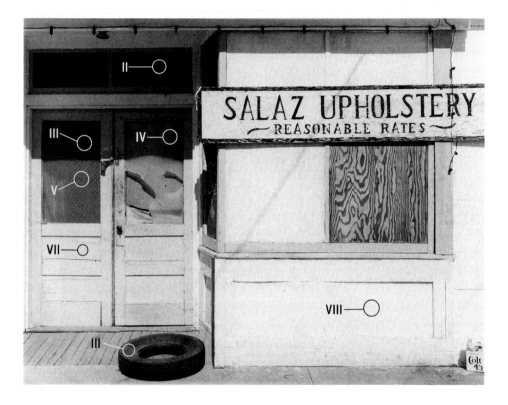

Figure 21: *The zones of a normal print.*

PREVISUALIZATION

Good photographers make a number of technical and aesthetic decisions before taking a photograph. In most cases, you must decide whether the photograph should be in color or black and white; a close-up or a long shot; vertical or horizontal. The Zone System extends this *before-shooting* decision-making process to include previsualizing the actual tonalities of the final print. This means looking at your subject and *mentally picturing* the way you want it to appear in the photograph that you are eventually going to make. For example, if you are photographing a model with brown hair, you will most likely want her hair in the finished print to be dark with all of its texture showing clearly. In other words, you want it to print in Zone III, or perhaps Zone IV if her hair is light brown.

Deciding beforehand that you would like her hair to be no darker than Zone III is important because if you inadvertently underexpose the film and her hair turns out to be Zone 0, you will be very disappointed.

Very often your intention will be to record the subject just as you see it. On the other hand, the range of creative possibilities is limited only by your imagination. Using your imagination is exactly what previsualization asks you to do. Whatever approach you decide to take, either recording your subject as is or interpreting it creatively, previsualizing the print before taking the picture is a very important skill to learn. The better you are able to previsualize the image that you are trying to make, the easier it will be for you to get the results you want.

Previsualization Examples: Dramatic and Subtle

The Zone System gives you the freedom to previsualize your subject in a variety of creative ways. You may for example want to create abstract images by greatly increasing or decreasing the subject's contrast. Figure 22A is an example of how an ordinary beach scene can be dramatically transformed by previsualizing it as a curving white pattern of foam against black sand and water. This image is the result of greatly underexposing and then overdeveloping the negative.

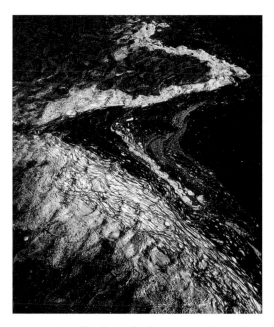

Figure 22A: Beach scene previsualized as a high contrast abstraction.

You will find, however, that even subtle alterations in the print's tonality or contrast can make an important difference in the overall impact of your image. You could, for example, decide to previsualize the background of your image as changing from middle gray to darker than it actually was, but still fully detailed. Using Zone System terminology you would say that the background should be Zone III instead of Zone V. The example in Figure 22B illustrates the difference this simple creative previsualization can make.

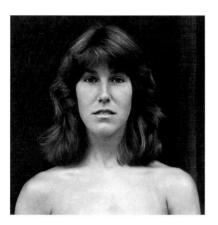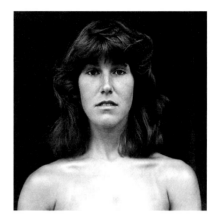

Figure 22B: *Two previsualizations of the same portrait.*

Both of the pictures in Figure 22B were photographed under the same lighting conditions and were printed on the same grade of paper. Figure 22B *left* is a normal view of the portrait. The tone of the wooden wall is approximately Zone V. Figure 22B *right* was produced by placing* the wall on Zone III and then expanding the contrast of the negative by increasing its development time.

The darker background and increased contrast of Figure 22B *right* draw your attention to the model's face, creating a more striking portrait. Many photographs could be vastly improved by a little forethought. With practice, you will find that previsualizing is not only simple to learn, but it also offers you a great deal of creative freedom. The important thing to remember is that *the way you previsualize your photograph will ultimately determine the way you will expose and develop your negatives.* The techniques for doing this are described in Chapters 5 and 6.

The following is an interesting exercise I recommend for photographers who are approaching the concept of previsualization for the first time.

*See "Placement" in the glossary.

Select a number of your favorite photographs from books, magazines, or your own collection and try to imagine how the actual subject may have looked if you had been at the scene. Is the image completely "natural-looking"? Some photographs are fairly straightforward, while others gain dramatic impact or subtle beauty by being somewhat more contrasty or soft than you would expect from natural lighting conditions. The works of Brett Weston, Minor White, Wynn Bullock, or Paul Caponigro are good examples of this. An exercise of this kind will teach you a great deal about the amount of creative control inherent in the art of photography.

MEASURING ZONES

The first two definitions of the zone link photographic prints to the visual world. For example, you could now say, "I want that person's face to print as Zone IV." The third definition of the zone establishes the same kind of relationship between zones and the tools of our trade, the *camera* and the *light meter*.

> **Note:** For the time being, I will limit my discussion to uses of hand-held light meters because these are the most functional for use with the Zone System. I will discuss built-in light meters in Chapters 5 and 7.

At this point, the important question is, How do zones relate to f/stops, shutter speeds, ASA numbers, and the numbers that light meters use to measure brightness?

The answer is that all these controls measure equal amounts of light. **F/stops, shutter speeds, meter numbers, ASA numbers, and zones all measure light according to a ratio of 2 to 1.** This means that whenever you see two of these numbers side by side, one represents *twice* as much light as the other. For example, f/8 exposes the film to *twice* as much light as does f/11 and *one-half* as much as f/5.6. Another way of saying this is that f/stops, shutter speeds, ASA numbers, and meter numbers all measure amounts of light that *double* going in one direction and *halve* going in the other. The ratio of light measurement between all photographic settings is 2 to 1.

Zones follow the same rule: Zone V represents *twice* the amount of light as Zone IV, *one-half* as much as Zone VI, and so on up and down the scale. This may sound complicated at first, but take a careful look at the chart in Figure 23.

ZONES	0	I	II	III	IV	V	VI	VII	VIII	IX
(1) Units of Light	1/2	1	2	4	8	16	32	64	128	256
(2) Arbitrary Meter Numbers	0	1	2	3	4	5	6	7	8	9
(3) Relative F/Stops	F/64	F/45	F/32	F/22	F/16	F/11	F/8	F/5.6	F/4	F/2.8
(4) Relative Shutter Speeds	1/250	1/125	1/60	1/30	1/15	1/8	1/4	1/2	1 sec.	2 sec.
(5) Relative ASA	6400	3200	1600	800	400	200	100	50	25	12

Figure 23: The equivalence of zones, meter readings, f/stops, shutter speeds, and ASA numbers.

Line 1 is labeled "Units of Light." Notice that Zone I is directly over 1 unit, Zone II over 2 units, and so forth. This indicates that if Zone I were said to equal 1 unit of light, Zone II would equal 2 units, Zone III would equal 4 units, Zone IV would equal 8 units, and so on. Their progression is *geometric*, meaning that each number *doubles* as it progresses upward.

In other words, the actual amounts of light the zones represent *double* as the zones get *lighter* and *halve* as the zones get *darker*. This is what is meant by a ratio of 2 to 1. Make sure that this is clear before reading on.

Line 2 shows that although the numbers that you see on the dials of hand-held meters progress arithmetically (1, 2, 3, 4, 5, etc.), they also represent amounts of light that increase geometrically. If meter number 1 equals 1 unit of light, meter number 2 will equal 2 units, meter number 3 will equal 4 units, and so on. This means that if you aim your meter at one wall and it reads number 6, and then you aim it at another wall and it reads number 7, the second wall is reflecting *twice* the amount of light when compared with the brightness of the first. Meters are designed this way because the manufacturer wants to avoid putting large numbers on the dial. Following the above analogy, meter number 11 would equal 1,024 units of light.

> **Note:** Meter numbers are said to be "arbitrary" because an amount of light that might read number 10 on my meter could read number 8 on yours. The same amount of light is being measured, but the numbers are different because the light meters are made by different companies. Exposure values (EVs) are standard from one meter to the next.

Lines **3** and **4** show that f/stops and shutter speeds are also calibrated according to a ratio of 2 to 1. The numbers themselves do not always double, but the amounts of light that they measure do.

Note: F/stops and shutter speeds are labeled as being "relative" because this chart intends to show how these numbers relate to each other: that they all measure equal amounts of light. Do not read this chart as indicating that f/11@ 1/8 will always give you Zone V. Your actual exposures will depend on the amount of light in your scene.

Line 5 illustrates that ASA numbers are also calibrated according to this ratio. If one film is rated **ASA 200** and another **ASA 400**, the second film is **twice** as sensitive as the first. It takes **one stop more exposure**, or two times the amount of light, for the first film to give the same results as the second. The rule to remember is: Using **half** the ASA number (ASA 400 to ASA 200) is the same as **doubling** the exposure; **doubling** the ASA cuts the exposure in **half** or, in other words, reduces it by **one stop.**

The fact that zones fit neatly onto this chart has far-reaching implications. Suppose you are photographing a scene with two walls; one wall reads meter number 5 and the other meter number 6. You could say that there is a one f/stop difference between them, or a one-zone difference. **By remembering that each meter number equals one zone, you can measure the contrast of any scene in terms of zones.** Let's say that the lowest meter reading you can find in a given scene is meter number 3. If the highest reading is number 10, you could describe this scene as having eight stops' worth of contrast, or eight zones' worth of contrast. As an exercise, try measuring the range of contrast in a variety of situations in terms of zones. Gradually, the equivalence of zones, meter numbers, f/stops, and shutter speeds will become clear.

SUMMARY

Let's briefly review what I have said about zones in this chapter.

Zones and the Print

Starting with a continuous spectrum consisting of all the possible tones in a print from black to white, zones are formed by following this procedure:

1. Divide the spectrum into ten equal sections.

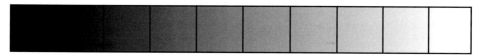

Ten-step divided spectrum.

2. Blend each section into one tone that represents all the tonal values in that section.

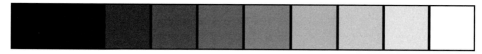

Ten symbolic tones.

3. Number each section with Roman numerals from 0 for the black section to IX for the white one.

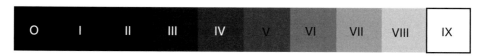

The Zone Scale.

Texture and Detail

1. In a fine print, each zone has a different amount of texture and detail.

There are three types of zones:

 a. Zones that have no texture and detail that are used to represent extremely dark or pure white objects in a photograph (Zones 0, I, and IX);

 b. Zones that have a limited amount of texture and detail that are used to represent very dark or light objects that are slightly textured (Zones II and VIII); and

 c. Zones with full texture and detail that make up the greater part of most photographs (Zones III, IV, V, VI, and VII).

2. Zones help us to mentally picture the subject being photographed in terms of the final print that we hope to make. This is called previsualization. Remembering how zones look in terms of subject matter makes previsualization relatively easy.

Measuring Zones

Zones represent amounts of light that double as the zones become lighter and halve as they get darker. In this sense, zones are equivalent to all other photographic controls. One zone equals one f/stop, one shutter speed, one meter number, and ASA numbers as they double and halve. This equivalency allows you to measure the contrast of any scene with f/stops, meter numbers, or zones. For the purposes of the Zone System they are all the same.

CHAPTER 5

Exposure

To understand how Zone System theory applies to exposure, let us first consider the different types of light meters that are available and how they function.

Light meters come in two general types: meters that measure what is called incident light, and meters that measure reflected light.

Incident-light meters measure the light that falls *on* the subject from the source of light (Figure 24). Incident-light meters are especially useful in lighting studios or on movie sets where the contrast can be controlled with fill-lights or reflectors. Under those conditions, your primary concern is to make sure that the amount of incident light falling on your subject does not change from one shot to another.

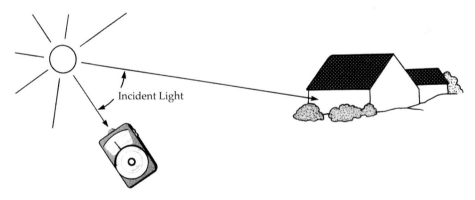

Figure 24: *Incident-light reading.*

Reflected-light meters measure the light that bounces *off* the subject to the camera and film (Figure 25).

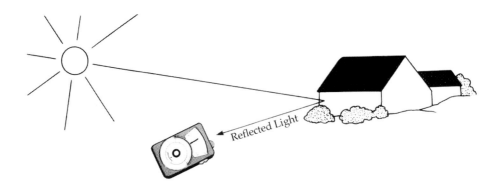

Figure 25: *Reflected-light reading.*

As we discussed earlier, with the Zone System, we are primarily interested in measuring the *contrast* of a given scene. The question is, How much light is coming from one area as opposed to another? Only a meter that measures reflected light can effectively tell us this difference.

There are three different types of reflected-light meters: spot meters, wide-angle meters, and built-in camera meters.

The first two types of reflected meters differ in terms of what is called their angle of incidence. A wide-angle meter "sees" at an angle of approximately 30 degrees, while a spot meter reads at an angle of only 1 degree or less in some cases (Figure 26).

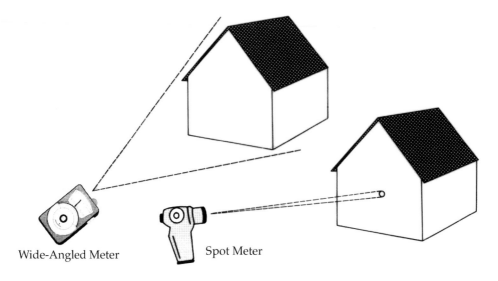

Wide-Angled Meter Spot Meter

Figure 26: *Wide-angle and spot meters.*

This is similar to the difference between looking through a straw as opposed to looking through a cone. The advantage of using a spot meter is that it allows you to measure the light from small, isolated areas very accurately at a distance. Imagine that you need to know how much light is being reflected by a model's face. With a wide-angle meter, you would have to get very close to avoid including her hair in the reading. This is less of a problem if you can approach the subject, but if you are photographing distant mountains or performers on a stage, a wide-angle meter can make getting an accurate reflected reading very difficult, if not impossible.

The acceptance angle of a built-in meter varies depending on the kind of meter the camera uses and the focal length of your lens. I will discuss built-in meters in detail later in this chapter.

Thus far, I have talked about "exposing for the shadows," or "making the background Zone III," without explaining how this is actually done. The problem of how to calculate the proper exposure becomes easy when you understand more about what a light meter is designed to do.

Light meters are programmed to perform *two different functions.* The first is to measure the **quantity** of light in terms of a meter number. In Figure 27, the meter is telling us that the wall being read is reflecting 15 units of light. Remember that these numbers are arbitrary. On another meter, the same amount of light might be number 11.

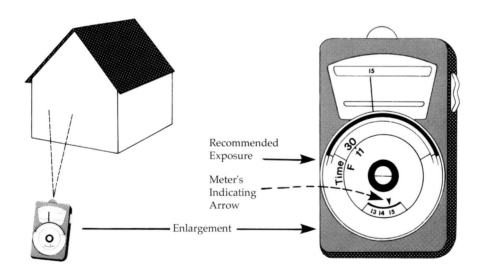

Figure 27: Meter reading.

The second thing a light meter does is to **convert** its reading into an exposure that you will use to take the picture. All light meters have an **indicating arrow** or pointer that is used to line up opposite the indicated meter number. When this is done, the meter's dial matches an f/stop with a shutter speed for the "correct" exposure. In Figure 27 the meter's indicated exposure is f/11 at 1/30 of a second. Unfortunately, finding the correct exposure is not always that simple. The problem is that light meters have no way of actually "seeing" the objects they measure. An exposure meter is simply a device that measures quantities of light. On a bright, sunny day, a dark wall might read meter number 11, but so might a light wall on a cloudy day. Think about this for a minute. "Seeing" is a complex process of visual perception that is much more than simply measuring amounts of light. For example, a piece of white paper looks white to you in both a light or dark room. In this case, to your eye, the light and dark walls are obviously very different, but to the meter, they are both *meter number 11.*

The light meter is responding to the change in incident light, but you can judge that the dark wall should print as Zone III and the light wall as Zone VII. Unfortunately, the meter still has the responsibility of suggesting the correct exposure for you to use. In this example, given that the meter reads both walls as number 11, it obviously cannot suggest the different exposures that the two walls would require. Light meters are designed to get around this problem in a simple way: **They lie.** Because the meter cannot tell that the dark wall is dark or that the light wall is light, it will simply pretend that both walls are **gray.** In this way, the exposure that it recommends can only be half-wrong at worst. Of course, if the wall had been gray in the first place, the meter's recommended exposure would have been perfect. The fact is that *all* light meters are programmed to give you an average gray exposure for whatever amount of light they are measuring.* In the language of the Zone System, we would say that **all light meters will automatically place any light reading on Zone V.** This is very important for you to understand and remember.

A simple demonstration that you can do with your own camera and film or with Polaroid materials will illustrate how this works.

Note: I strongly recommend that any reader approaching the Zone System for the first time stop and work this demonstration through to the end before going on. Not only will it graphically illustrate the way light meters operate, but it will also function as an ideal warm-up for Zone System testing.

*Some exceptions to this rule will be discussed later.

Before you begin, it is a good idea to have your light meter and shutter speeds tested for accuracy and consistency. If your technician advises you that your equipment tests within reasonable limits, proceed with this demonstration. If not, leave the equipment with the technician to be adjusted.

Exercise: How Light Meters Really Work

To do this demonstration, all you need are four frames on any roll of film, two walls (a light one and a dark one), and a reflected light meter. A "Zone V" Neutral Gray Card from Kodak will be useful when you make a contact print of these test exposures.

In choosing your test subjects, try to select walls that match your mental image of Zone IV for the dark wall and Zone VI for the light wall. This will be your first exercise in previsualization. It is very important that you find evenly textured surfaces and that you fill the frame of your camera with only those areas before you shoot. Be careful not to include your shadow in the image.

If your camera is equipped with an automatic built-in meter, you will either have to set it to its "manual" setting or override the automatic function; otherwise when you stop down one stop, the meter will automatically change the shutter speed to one step slower in order to maintain its Zone V exposure. Check your owner's manual if you are not clear on how this is done with your camera. See page 81 for a discussion of how to override automatic built-in light meters.

Exposure Plan

FRAME 1: Take a careful meter reading of the dark wall and make an exposure of only that surface **using the meter's recommended f/stop and shutter speed.** With built-in meters, center the dot or arrow of the meter and shoot.

FRAME 2: Make an exposure of the same dark wall using an exposure

> **Note:** Be sure to take your light reading at the same angle you intend to shoot the picture and that you use the correct ASA for the film you are using. If your camera has a compensation control dial, be sure to set it at zero.

that is **one stop less** than the first. Do this by either stopping down one f/stop from the first exposure or using one shutter speed faster. I will explain the purpose of this adjustment later in this chapter. The goal of this step of the exercise is to **underexpose** the film by one stop (Zone IV) when compared to the exposure used for frame 1.

FRAME 3: Carefully meter and shoot the light wall **using the meter's recommended exposure.**

FRAME 4: Photograph the light wall using an exposure that is **one stop more** than the meter's recommended exposure. For frame 4 you will be **overexposing** the film by one stop (Zone VI) when compared to frame 3.

FRAME 5: Put the lens cap on your lens and shoot one blank frame.

Process this roll of film using your standard development time and make a contact print of your five test frames. Choose an exposure time for this contact print that is the minimum amount of exposure under the enlarger that it takes to make your blank frame (frame 5) as black as it will get. To find this time, make a series of test exposures at two-second intervals across frame 5. The first exposure step that turns this unexposed frame as black as the paper will get represents your minimum time for maximum black. For a detailed explanation of this procedure, see Chapter 8, page 102.

Your four other test frames should something look like this:

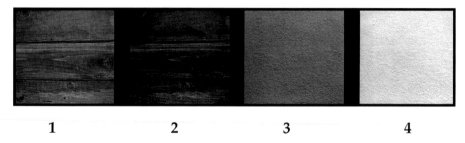

| 1 | 2 | 3 | 4 |

Figure 28: Zone placement test frames.

Notice that frames 1 and 3 are very similar in tone (they should approximately match your Neutral Gray Card). This is because the meter is blindly trying to give you the correct exposure by averaging the dark and light values of the walls to middle gray (Zone V). Frames 2 and 4 should be much closer to the actual tonal values of the original walls.

> **Note:** A valuable extension of this demonstration would be to expose two rolls of film in exactly the same way using the procedure described above. Develop the first roll using your standard development time and the other at a time that is 20 percent longer. Contact both rolls at times that allow the first and third frames to match your Neutral Gray Card. What you will notice is that while the frame 2s on both rolls are very similar in tone, the frame 4s are noticeably different: the frame 4 (in Figure 28) that has been developed for 20 percent longer is noticeably lighter. This illustrates the effect of increased development on the highlight values, as described in Chapter 3.

EXPOSURE PLACEMENT DEMONSTRATION WITH POLAROID FILMS

The advantage of doing this demonstration with your own materials is that it will give you an opportunity to test your ability to solve a simple exposure problem. On the other hand, the fastest way to see the result of this process is to work with either Polaroid's black-and-white Polapan slide film (ASA 125) or any color Polaroid camera.

The exposure procedure with Polaroid slide film would be the same as described above for normal black-and-white films. The difference is that you will end up with slides that you can view with a projector to see your results.

With any Polaroid color camera, photograph a dark and a light wall. It is important that you fill the frame with each wall so that none of the surrounding area is included in the image. Also, to obscure any surface detail, do not focus the camera, if this is possible. When both pictures are developed, you will see that they bear little resemblance to the two walls. In fact, if you have done this correctly, the two pictures should be very similar in tone. Any difference between the two images will be the result of the different response that the color film has to different colors and to the compensation that the meter makes to very high or low light values. The point is that the two pictures will be *much* closer in value to each other than they are to the walls themselves.

The Results

What this demonstration shows is that the camera's built-in meter is programmed to render **any single subject value as an average middle gray tone, or Zone V, regardless of how dark or light it may actually be.** With a few exceptions I will discuss later, all light meters are designed the same way.

What you should have learned from this demonstration is that if you were always to follow the meter's recommendations, it would be a classic case of the blind leading the blind: you see the wall as a dark value, the meter sees it as gray, and the meter's choice prevails. To achieve the correct exposure consistently for any subject, **you need a way to tell the light meter how you want the walls to print.** When you apply all that you have learned thus far, the method for doing this will seem very simple.

To demonstrate the Zone System method of exposure, imagine that Figure 29A is an actual subject that you are trying to photograph.

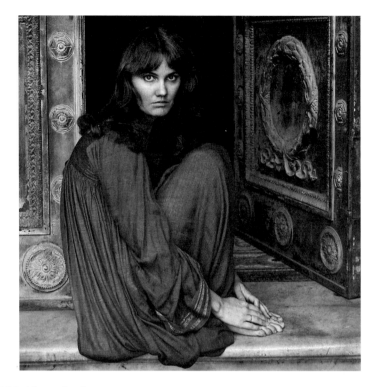

Figure 29A: Normal print.

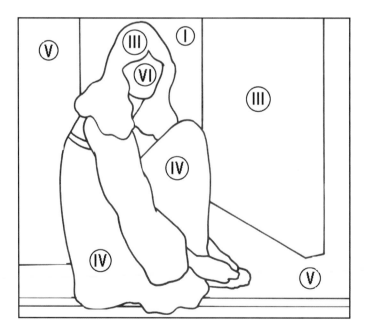

Figure 29B: Zone placements of Figure 29A.

Exposure Detailed

The first step in taking any photograph is previsualization. In terms of deciding how to expose a given subject, the important question in most cases will be, **what part of this picture do I want to print as Zone III?** Zone III is important because it is the darkest zone that shows **full texture and detail.** Remember that the rule is to **expose for the shadows.** Take a careful look at Figure 29A. Imagining that this is an actual scene, which areas would you judge to be Zone III? The obvious answers are the model's hair and the darker parts of the door on the right. For brown hair to print realistically it has to be detailed enough to show individual strands. This automatically indicates Zone III. Blond hair is closer to Zone VII.

PLACE AND FALL

The concept of zone **"placement"** is extremely important in Zone System theory because it describes the process that will ultimately determine your exposure. In any photographic subject, you will always find some dark area that in your opinion *absolutely needs* adequate texture and detail. This part of your image is called the **Important Shadow Area.** After you have selected the Important Shadow Area, your goal in most cases will be to choose an exposure that will render that area as **Zone III** in the finished print. This is called **placing the Important Shadow on Zone III.** See Figure 29B. Remember that Zone III is the first dark zone that has full texture and detail.

When you decide to place a particular area of the subject on Zone III, you are saying in effect that you will not mind if any inherently *darker* area of the scene is black or nearly black in the finished print. Another way of putting this would be to say that **after the Important Shadow has been placed on Zone III, darker areas of the subject will fall on Zones 0, I or II.** The dark interior behind the model's head in Figure 29A is a good example of an area that should logically fall below Zone III. You can see why the placement of Zone III is so important. Placing Important Shadow Areas of your subject too low on the Zone Scale is an excellent way to define underexposure. In this example, the model's hair would be lost against the dark interior of the building if it were placed on a zone lower than Zone III.

Areas of the subject that are inherently *lighter* than the placed shadow value will logically fall on zones *above* Zone III. If the **Important Highlight Areas** of your subject fall above Zone VIII, they will be too white in the print or "blocked up," as we say. The relative positions of all the values in the subject are determined by the placement of the Important Shadow Area on the Zone Scale. If you place your shadow value on a

lower zone, all the other subject values will be darker. placing the shadow value higher on the Zone Scale will cause the rest of the subject values to be lighter. I will discuss further implications of this statement in Chapter 6.

Once you have decided on the placement of Zone III, your last exposure problem is choosing the correct f/stop and shutter speed. You need only remember the following:

With Hand-Held Meters

1. Your meter will automatically place any meter reading on Zone V if you put that number under the meter's indicating arrow.
2. Each meter number is equivalent to one zone and/or one f/stop or shutter speed.

With In-Camera Meters

1. The meter's recommended exposure (when you center the needle or dot), will place whatever the meter is reading on Zone V.

2. Each f/stop or shutter speed is equivalent to one zone.

The first step in determining the correct exposure in this example is to meter the model's hair carefully (previsualized as Zone III). With a spot meter, you could obtain an accurate meter reading without leaving the position of the camera. With a wide-angle or built-in meter, you would have to get close enough to the model for her hair to fill the meter's field of view. You would also have to avoid including the shadow of your hand in the reading. As illustrated in Figure 30, the spot-meter reading for the model's hair is 9. If you were to put meter number 9 under the meter's arrow (blindly following the meter's instructions), the recommended exposure for this portrait would be *f/11 at 1/30 of a second.*

Note: Built-in meters do not have meter numbers and instead, translate light readings directly into recommended f/stop and shutter speed exposures.

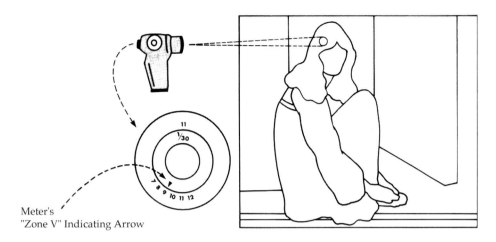

Figure 30: *Zone V placement of meter number 9 (the model's hair). Meter recommended exposure: f/11 at 1/30 of a second.*

Because the meter's recommended exposure will cause her hair to print as Zone V (in this case, two zones **lighter** than you want it to be), if you **stop down two stops from this suggested exposure** (from f/ 11 to f/22), you will be placing the meter reading of her hair on Zone III, which is the way it should be printed. ***This is a key point, so consider this step very carefully.*** The reason that you stop down *two* stops is that one stop less exposure would place her hair on Zone IV, whereas two stops less exposure will place her hair on *Zone III.* Frame 2 of Figure 28 was placed on Zone IV.

Of course, you may use either f/stops or shutter speeds to make this adjustment because zones, shutter speeds, and f/stops are equivalent. The corrected exposure would then be f/22 at 1/30 of a second.

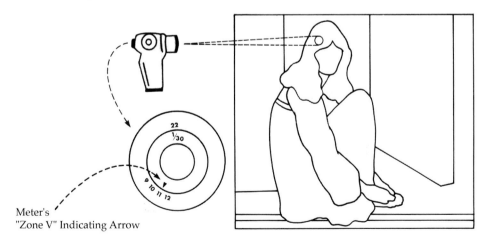

Figure 31: *Zone III placement of meter number 9 (the model's hair). Corrected exposure: f/22 at 1/30 of a second.*

Your concern with determining the exposure of this portrait ends here. The model's hair and the door have been safely placed on Zone III (in this example, the meter reads them as the same meter number), and the darker parts of the scene are falling on the lower zones where they belong.

SUMMARY

Unfortunately, explaining this procedure in detail makes it appear much more complicated than it really is. In essence, all you have done is:

1. Decide which areas of the scene you want to be on Zone III in the final print (in this case, the model's hair).
2. Meter that area and align the meter's Zone V indicating arrow with the meter number.
3. Make note of the exposure that the meter is recommending, in this case, f/11 at 1/30 of a second.
4. Stop down two stops from this recommended exposure to place her hair on Zone III. The corrected exposure would be f/22 at 1/30 of a second.

If you are using a built-in light meter, the procedure would be a little different:

1. Previsualize your Zone III area.
2. Get close enough to your subject so that this area fills the viewfinder.
3. Center the needle or dot and note the exposure that the camera's meter is recommending.
4. Stop down two stops from this recommended meter reading to place that area on Zone III.
5. Using this new exposure, step back and take the picture.

See page 81 for a discussion on overriding automatic built-in metering systems.

Some people have difficulty believing that the Zone System is really that simple, or they have trouble "disobeying" their meters. If you think through this example, however, you will see how logical it is.

You now have a reliable way of using your light meter as a tool to give you the correct exposure according to your previsualization. If you were to previsualize a light wall as Zone VII and were unconcerned about any shadows that might be in the picture, you would simply meter the wall and open up two stops from the meter's recommended exposure. Opening up one stop would place the wall on Zone VI. (See frame 4 of Figure 28.)

Of course, for all of this to work properly, it is important that you use the correct ASA for the film you are using. I will discuss this factor in detail in Chapter 7. The effects of reciprocity failure, filter factors, and bellows extension are covered in Appendix H.

The problem that most beginners have with this process is previsualization. Previsualizing is an act of aesthetic judgment that offers you a wide variety of choices. There are obviously a number of effective ways to interpret any given subject. While you are learning this process, I would suggest that you stick to "normal" previsualizations of your subjects. Later, when you are sure that you can consistently produce realistic results, begin experimenting with alternative ways of seeing.

Other problems that many of us have with previsualizing black-and-white photographs are the associations we have with certain colors. Most people judge a blue object to be darker than a red one, even if both objects are actually reflecting the same amount of light. A handy device for dealing with this problem is a panchromatic viewing filter. Looking through this brown-colored filter removes most of the color from the scene and reveals the inherent contrast as the black-and-white film will see it. A Kodak Wratten Filter Number 90 will give you approximately the same effect and is usually much less expensive. See Appendix L for details on where to order this and other materials designed especially for Zone System use.

CHAPTER 6
Development

Placing an Important Shadow Area on Zone III guarantees that your negatives will be properly exposed. In this chapter, we will consider the effect this has on the other values of the scene. The important questions are, where does the Important Highlight Area fall on the Zone Scale, and how does this affect your development time? The rule is to **develop for the highlights**. This means that the correct development time for a given negative depends on the amount of contrast in each scene you photograph.

At this point, photographers with 35mm cameras begin to wonder how each frame of a roll of film can be developed individually. There is no practical way to do this but there are many ways of adapting roll-film procedures to this rule. I will discuss these after covering the basic theory.

> **Note:** For clarity, I will be using hand-held meter readings with Exposure Value numbers in these examples. (Refer to Chapter 4, page 35). See "Measuring Subject Contrast with Built-In Meters" on page 58 for a description of how these principles apply to those meters.

Let's consider the effect of measuring the contrast of different subjects in terms of zones. Once again, imagine that the portrait in Figure 32 is an actual scene.

The model's black skirt is previsualized as Zone II, the dark foliage as Zone III, her face as Zone VI, and her blouse as Zone VII. Figure 33 indicates the spot-meter readings for the previsualized areas of the subject. The numbers indicated are the average meter readings of those areas.

Figure 32: Normal contrast subject. Negative given Normal Development.

The first step after previsualizing your subject is to place the Important Shadow Area on Zone III. Placing the foliage (meter number 6) on Zone III can be diagrammed like this:

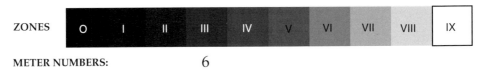

Figure 32A: Meter reading number 6 placed on Zone III.

Figure 33: Spot-meter readings of Figure 32.

Maintaining the "one meter number for one zone" relationship, the other meter readings for this scene can be filled in under the appropriate zones as follows:

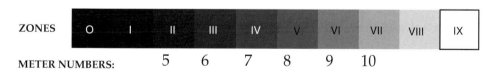

Figure 34: Meter number 10 falls on Zone VII.

The principle at work here is very simple. After the selected subject value has been placed on a zone (in most cases you will be placing the Important Shadow Area on Zone III), all the other subject values have to fall on the other zones of the scale. The specific zones on which the other meter readings fall will depend on how much lighter or darker they are than the placed value. In this way, you are actually **measuring the contrast of your subject in terms of zones.**

A good analogy for this process would be measuring a piece of fabric. Imagine that the cloth is five inches long (or five zones in this case). If you "place" one end of the fabric on the three-inch mark of a ruler, the other end of the cloth has to "fall" on the eight-inch mark.

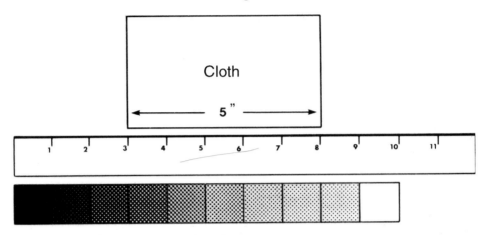

Figure 35

In this first example, we are using the Zone Scale to measure the portrait's range of contrast by seeing where the meter readings of the relevant subject areas fall. As you can see in Figure 34, placing meter number 6 on Zone III means that meter number 5 has to fall on Zone II because the subject's skirt is reflecting one-half as much light as the foliage. Meter number 7 has to fall on Zone IV because the subject's skin is twice as bright. We can now say that this scene has a range of contrast equal to six zones, from Zone II (meter number 5) to Zone VII (meter number 10).

Having placed meter number 6 on Zone III, meter number 8 will fall on Zone V. If you move the meter's dial to that number, you will have all the correct exposures for this portrait. Think this through: The meter's indicating arrow is always in the correct position when it is pointing to the number that you want to fall on Zone V. Your Zone III placement will **always be two meter numbers less** than this Zone V number. This suggests a simple method of operating your meter. After you determine what meter number you want to place on Zone III, simply **add 2** to that number and move the indicating arrow to the result. See Figure 36.

Now that we have used the Zone Scale to measure this scene's contrast, all that remains is to see how this compares with our previsualization.

Remember that we previsualized this portrait as follows: skirt on Zone II, dark foliage on Zone III, face on Zone VI, and blouse on Zone VII. Figures 33 and 34 show that all the key meter readings of this scene are falling on the appropriate zones.

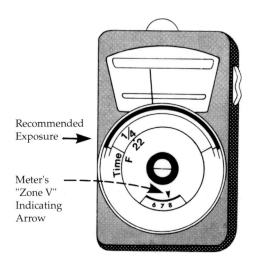

Recommended Exposure →

Meter's "Zone V" Indicating Arrow

Figure 36: Placing meter number 6 on Zone III.

When a subject value previsualized as Zone VII falls on that zone after the Important Shadow Area has been placed on Zone III, the contrast of the scene can be considered Normal and the negative should receive Normal Development. Remember that Normal Development is the standard development time for a given film and developer that will give you contrast in the negative equal to the contrast of the scene. (Refer to Chapter 3.)

Because the contrast of this portrait is Normal (and because the placement of the shadow value is correct), Normal Development will result in a negative that will print well on a normal grade of paper, usually grade or filter 2. Of course, the effective Normal Development Time for your film and developer can be determined only by testing them under controlled conditions. A simple testing method is outlined in Chapter 8.

Note: Keep in mind that by "Normal" contrast I do not mean that all the subject's values must fall exactly on the previsualized zones. What I mean is that the overall contrast of the scene should match the normal limits of the film and paper and that all the other middle values of the subject will fall somewhere within the five zones of the textural scale. In other words, do not be surprised if the meter reading for the face in a portrait falls on Zone V 1/2 or VI 1/2. Even when you are working with properly exposed and developed negatives, it is necessary to dodge and burn in selected areas of the print to add emphasis or to correct tonal imbalances. Fine printing will always be an art unto itself.

Let's review what we have done so far:

1. First, meter the area that you have previsualized as the textured shadow area and place that meter reading on Zone III. See Figure 34.
2. Next you should note which meter number falls on Zone V and turn the meter's Zone V indicating arrow to that number to determine the correct exposure. See Figure 36.
3. If the meter number for the area of the subject you want to print as Zone VII falls on that zone, you should give the negative Normal Development.

Measuring Subject Contrast with Built-In Meters

The principles you have just learned apply as much to in-camera meters as any other type but the above examples may have been confusing because built-in meters do not use meter numbers that would make the process as logical as my illustrations. Instead of using EV numbers, an in-camera meter translates its readings of the Important Shadow and Highlight areas directly into recommended f/stop and shutter speed combinations. Here is how to use an in-camera meter to measure the contrast of any subject:

1. Get close enough to fill the frame of your camera with the Important Shadow Area (previsualized as Zone III).

2. Take a meter reading of that area and make note of the meter's recommended exposure. (For example: f/5.6 @ 1/8 sec.)

3. Take a careful meter reading of the Important Highlight Area (previsualized as Zone VII) using the same shutter speed as the previous reading. (For example: f/22 @ 1/8 sec.)

4. Notice that there are **five f/stops** difference between these two readings. By keeping the shutter speed the same, you have measured the contrast between these two surfaces using your apertures. **Following the rules you have learned, you can now say that there are five stops, or five zones difference between these two areas.**

Also notice that the meter is recommending a wider aperture for the dark surface and a smaller aperture reading for the Important Highlight Area. This is because the meter is trying to make both areas look middle gray (Zone V). It takes more light to make a black surface look gray, and less exposure to make something white look gray. Look back to Figures 32A and 34 and replace the meter numbers used in those examples with these f/stops to see how this works.

NORMAL PLUS DEVELOPMENT

In this next example, the problem is making a printable negative from a scene that has *too little contrast*. The photograph in Figure 38 was taken on a very gray and overcast day. The print is dull and lifeless because the negative was given Normal Development and printed on a Normal grade of paper. (Refer to pages 60 and 61).

In this case, the model's hair and shawl were previsualized as Zone III, her face as Zone VI, and her shirt as Zone VII. Figure 39 shows the meter readings for these areas of the portrait.

When you place the Important Shadow Areas on Zone III (in this case, both her hair and shawl read meter number 7), notice that the meter reading for her face (9) falls on Zone V, and the reading for her shirt (10) falls on Zone VI. As you can see, all the Important Highlight Areas of this subject are falling **one zone below** where you want them to be according to our previsualization. **The remedy is to expand the contrast of the negative with increased film development.**

As always, you can determine the correct exposure by turning the meter's arrow to the number that falls on Zone V, in this case meter number 9. (See Figures 37 and 39).

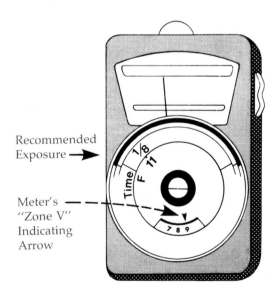

Figure 37: Zone III placement of meter number 7.

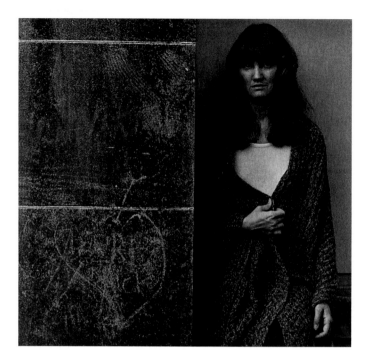

Figure 38: *Low-contrast subject. Negative given Normal Development.*

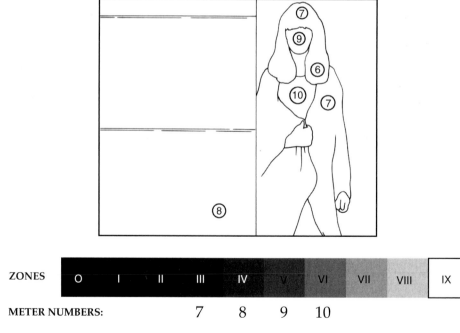

Figure 39: *Spot-meter readings and zone placements of Figure 38.*

Figure 40: *Low-contrast subject. Negative given N + 1 Development.*

To compensate for the lack of contrast in this subject, you must increase the development time of the negative enough to raise a Zone VI negative density to Zone VII and a Zone VII density to Zone VIII. This increase is called **Normal Development Plus One zone,** or **N+1**. Remember that increasing the development time does not affect the shadow densities as much as it does the highlights. (Refer to Chapter 3.)

By systematically increasing the highlight densities by one zone, you can produce a negative that has properly exposed shadows and more contrast than the original scene. The resulting print matches our previsualization and has a much better sense of light.

Figures 41 and 42 illustrate the effects of N + 1 and N + 2 Development, respectively.

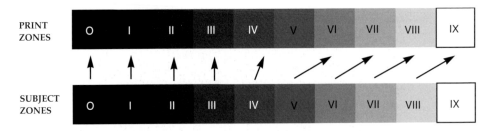

Figure 41: *The effect of Normal Plus One (N+ 1) Development.*

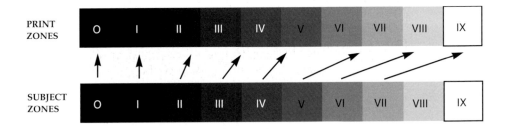

Figure 42: *The effect of Normal Plus Two (N + 2) Development.*

The lines labeled "Print Zones" represent the zones of the subject as you previsualize them in the final print. The lines labeled "Subject Zones" represent the contrast of flat subjects measured in zones. Notice that when a negative is given N + 1 Development, Zones VI, VII and VIII will increase in density by **one full zone**. The zones that are below Zone V increase much less. Zone IV increases by only one-half of a zone, and Zone III *hardly moves at all.* Zone V can be considered the borderline between the zones that will increase *proportionately* with longer development and those that will not. Because the zones below Zone V increase in density at a much slower rate, increasing the development time of the negative increases its contrast. You can determine the exact times for negative expansions by doing tests that are outlined in Chapters 8 and 9.

To summarize, the way to produce usable negatives from subjects with very little contrast is to *expose for the shadows,* then *increase* the negative's development time enough to raise the highlight densities to the proper previsualized zone.

> **Note**: Extreme Normal Plus Development will result in grainier negatives, which could be a problem for those working with roll-film cameras. An alternative method for increasing the contrast of 35mm negatives without added grain would be to intensify your film in selenium toner. For more information about this process, refer to Appendix B.

A good question to ask at this point would be, Why not simply place the shadow reading in this example (meter #7) on Zone IV instead of Zone III? Your placement would then look like this:

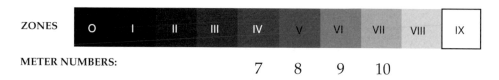

Figure 43: *Meter number 7 placed on Zone IV*

The highlight reading is now falling on the proper zone, but notice that you have effectively overexposed the negative without increasing its contrast. The result would be a print with gray, flat shadow areas.

NORMAL MINUS DEVELOPMENT

The problem in this case is the opposite of the one in the previous example. Here the combination of bright sunlight and white surfaces causes this to be a very contrasty photographic subject. The goal is to show detail in the shadow areas (in this case, the model's shawl) while maintaining the subtle texture and brilliance of the highlights. If you were to place the shadow readings on Zone III and give the film Normal Development, the result would be a negative with overly dense highlights. In the print, these nearly opaque densities will appear as empty, glaring whites with no tonal separation or surface detail.(See Figure 44).

Notice that the shadow areas are properly rendered, indicating that the exposure is correct but that the highlights are washed out. A reduction in the negative's development time is required, but the question is how much?

The model's shawl is previsualized as Zone III, her face as Zone VI, the shadows on the wall as Zone V, the sunlit wall as Zone VII, and her white jacket as Zone VIII. Figure 45 indicates the spot-meter readings for these areas.

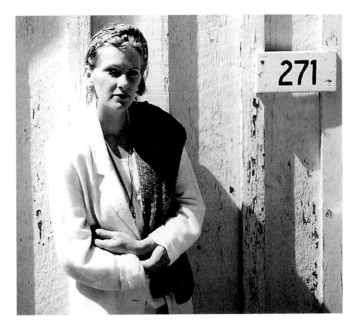

Figure 44: High-contrast subject. Negative given Normal Development.

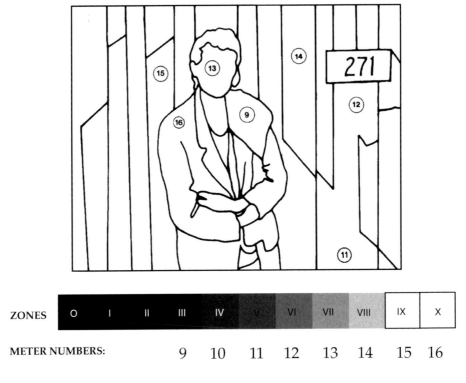

ZONES	O	I	II	III	IV	V	VI	VII	VIII	IX	X
METER NUMBERS:				9	10	11	12	13	14	15	16

Figure 45: Spot-meter readings and zone placement of Figure 44.

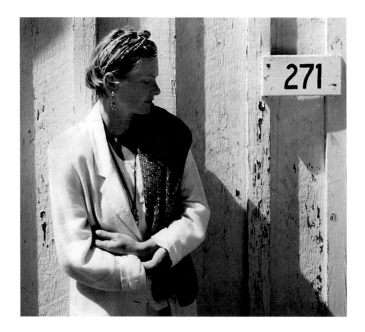

Figure 46: *High-contrast subject. Negative given N-1 Development*

Don't be confused by the sudden appearance of Zone X. For the first time we are using the Zone Scale to measure the contrast of a very contrasty scene. The extra zone space gives us a place to record where this very high reading falls.

As you can see, when meter number 9 is placed on Zone III, all the highlights fall **one zone higher** than our previsualization. The correct exposure is determined by turning the meter's arrow to 11 (Figure 47).

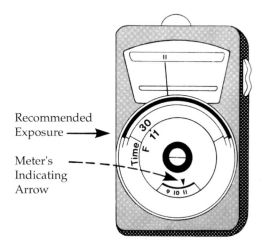

Figure 47: *Zone III placement of meter number 9.*

The next step is to give the film less than Normal Development to reduce the density of the negative's highlights. Because the highlights of this portrait are falling one zone too high, the correct development time for this negative would be **Normal Minus One zone**, or **N - 1** (Figure 46). The resulting print has well-detailed shadows and textured, luminous highlights. Refer to pages 64 and 65.

The effects of N - 1 and N - 2 Development are illustrated in the following examples.

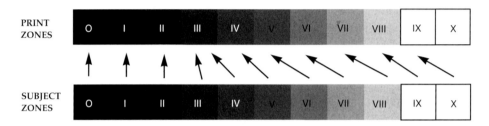

Figure 48: *The effect of Normal Minus One (N-1) Development.*

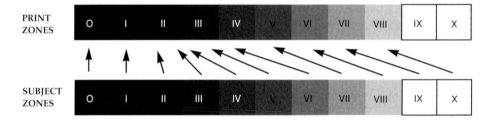

Figure 49: *The effect of Normal Minus Two (N-2) Development.*

Notice that with N - 1 Development, a Zone VIII negative density is reduced to a density equivalent to Zone VII, while Zone IV only decreases to Zone III 3/4. Because the higher zones decrease in density much more than the zones below Zone V, **shortening the development time has the effect of reducing the overall contrast of the negative.** Again, you can determine the exact times for negative contractions by testing your film and developer. It is important to note that when the film is given less than N - 2 Development, there is a noticeable loss of negative density in the lower zones. The remedy for this problem is simply to remember to place your Textured Shadow reading on Zone IV instead of Zone III when the contrast of the scene is extremely high. For further discussion of the effects of extreme Expansion and Contraction, refer to Appendix B.

CHAPTER 7
An Overview of the Zone System

This chapter briefly summarizes the Zone System method of exposure and development and answers a number of questions usually asked by students at this point in the process.

What we have learned is that when the contrast of the subject being photographed is flat or contrasty it is necessary to control the contrast of your negatives.

Here are the steps for producing consistently printable negatives:

1. Previsualize your subject in terms of the finished print. This means that you should mentally assign a zone to the important textured areas of the subject.

To choose the correct exposure you need to decide which parts of the picture you want to be Zone III. Zone III is the zone for the area of the subject that you want to print as a fully textured shadow value.

To determine the correct development time for the negative you need to identify the Zone VII area of the subject. Zone VII is the zone for textured highlights. (See Figure 50.)

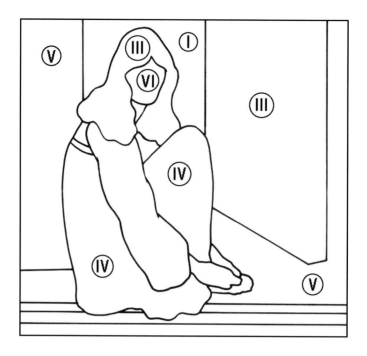

Figure 50: Previsualization.

2. Determine the correct exposure by carefully metering the Important Shadow Area and placing it on Zone III. This is done by stopping down two stops or two shutter speeds from the meter's recommended Zone V exposure for that area.

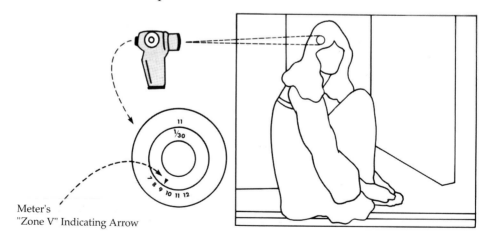

Meter's
"Zone V" Indicating Arrow

Figure 51: Placing meter number 7 on Zone III, the correct exposure for Figure 50 is f/11 at 1/30 of a second.

3. Measure the subject's range of contrast in terms of zones by plotting the meter readings of the scene against a Zone Scale. To do this, write the reading of the Textured Shadow Area on the form under Zone III, then apply the rule: **One meter number equals one zone.**

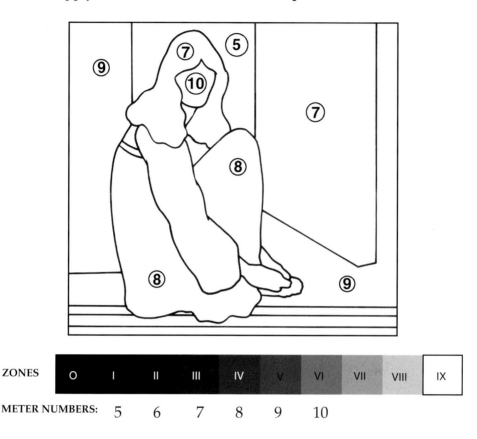

Figure 52: Placing the textured shadow reading on Zone III.

> **Note:** The shadow reading is the only one you need at this point. Eventually you will find that you will not need to write these numbers down, but in the beginning, doing so will make it easier for you to keep track of which meter number falls where on the scale. You can make a form of your own, but for information on where to obtain printed Zone Scales and Exposure Records, refer to Appendix L.

4. Determine the correct development time for the negative by carefully metering the areas that you have previsualized as Zone VII (or Zone VIII depending on the subject matter). If this meter reading falls on the proper zone after the textured shadow has been placed on Zone III, give the film Normal Development.

5. If the meter reading for the Important Highlight Area falls above or below the previsualized zone, increase or decrease the film's development time according to how many zones away from the previsualized zone it falls. For example, if the Important Highlight Area falls one zone above the previsualized zone on the Zone Scale, the recommended development time would be Normal Minus One zone (N - 1). These numbers should be written directly on the film holder or cassette to avoid confusion.

EXPOSE FOR THE SHADOWS AND DEVELOP FOR THE HIGHLIGHTS

The Zone System method of negative contrast control is as simple as that. Once you appreciate the importance of properly exposing and developing your negatives, it simply becomes a matter of working with the system long enough for the principles to become familiar. Your first attempts at applying the Zone System to your photography might make you very aware of other weaknesses in your technique. No system, however logical or straightforward, can compensate for faulty equipment or carelessness. If you are persistent, you will eventually work out all the bugs and develop your own set of shortcuts. At that point, your work will begin to flow smoothly.

One of the first steps in this process is losing your anxiety about making a mistake. This is why the test outlined in the next chapter is so important. After you produce your first successful print with the Zone System, the mystery will disappear.

One of the misconceptions about the Zone System is that it will make photographic printing routine. The goal is not to make photography an exact science but rather to allow photographers to concentrate on the parts of the process that require intuition and imagination. What you will find is that a little bit of understanding and control will go a long way towards solving your technical problems. Once the negative is made, the issue becomes, how to best interpret it through creative printing.

When you begin using the Zone System, you may encounter some of the following problems.

First, you may have trouble previsualizing the subject in terms of zones. Any new system takes a while to get used to, but before long you will find that it comes naturally. Keep in mind that for the purpose of determining the correct exposure, the only question you need to answer is "Where is the area that I want to be Zone III?" Look for an area of the subject that would spoil your photograph if it were too dark in the finished print. Most likely this is the area you want to place on Zone III. Again, it is useful to spend time studying other photographers' work to help you develop a sense of your own standards. If you have a 4 X 5 view camera with a Polaroid adapter back, it is a good idea to practice previsualizing a variety of subjects to see how the results either confirm or modify your previsualizations. You may also try using a panchromatic viewing filter as an aid.

The second important question you need to answer for the correct development time is "Where is the Zone VII area of this subject?" Practice will make this easier, but a good rule of thumb is, *if the area in question is light colored and textured, call it Zone VII.*

It is easy to overdo trying to pinpoint specific zones. At first it may be difficult to "see" Zone VII when the contrast of the subject is very flat. The lack of an obvious light value in the subject could make previsualizing Zone VII seem illogical. It could also be that you might not want a Zone VII in that particular image. In this case, consider Zone VI to be the Important Highlight zone for this image and develop the film accordingly. This also applies to Zone III. If you decide that Zone II is the appropriate zone for the Important Shadow Area of your subject, place your meter reading on Zone II and start from there. (The only danger with this approach is that you cannot change your mind after taking the picture and give that area more exposure later.) The purpose of the Zone System is to give you creative control, not to lock you into hard and fast aesthetic limitations. Whenever you are in doubt about how to proceed with a given image, make a decision and pay careful attention to your results. Be sure to keep careful records when you are unsure. In general, you can count on the obvious associations I have mentioned before: light clothing, concrete, and white objects in the shade are usually Zone VII. Dark foliage, dark clothing, and brown hair are commonly Zone III. Paper and white objects in sunlight are generally Zone VIII.

Third, Zone System beginners often become confused about which way to turn the meter dial to place a shadow value on Zone III. At first it is easy to turn the dial the wrong way and drastically overexpose the film. I would say that this is by far the most common mistake made by students when they first begin learning the system. The key is to remember that

you are trying to make the Zone III area of the subject darker than the meter is telling you to. As you turn the dial, watch to see whether the exposures are becoming longer or shorter. If, for example, turning the dial to the right decreases the exposure, memorize that direction for future use.

Many light meters have enough room adjacent to the meter numbers to attach a small Zone Scale like the one illustrated in Figure 53.

Figure 53: *How to place meter number 10 on Zone III using a Zone-Scale decal.*

Self-adhesive decals of this kind are available from Fred Picker's Zone VI Studios (see Appendix L). If this is possible on your meter, be sure you line up the scale with the Zone V section over the meter's indicating arrow. A scale like this will make zone placement and contrast measurement almost ridiculously easy. For example, when you want to place a given meter number on Zone III, all you need to do is turn the dial until that number is under the Zone III section of the scale. You can now read the correct exposures and the relative positions of all the other meter numbers directly from the dial. A visual aid like this makes it very easy to think through the placement and exposures you will want to use. Actually seeing the meter readings falling on the rest of the scale will make the process much more concrete.

Another common problem is faulty equipment. After carefully metering, exposing, and developing an image, you may discover that it is ruined because of a seriously inaccurate light meter or shutter. You are less likely to notice a problem like this when you are not sure of what you are doing. It is a good idea to take your meter and shutters to a good camera repair store to have them checked before you begin trying to improve your technique.

Let's consider some of the questions commonly asked about the Zone System.

Q: **The procedure you have described is fine for situations where there is plenty of time to take careful readings. What should I do if I have to shoot quickly?**

A: In all of the previous examples, I have included meter readings for all the important areas of the subject in order to make the process more clear. Practically speaking, there are only *two meter readings* that you absolutely must make. You need one reading of the Important Shadow Area to calculate the exposure (at this point, you can take the picture); and one reading of the Important Highlight Area to determine the proper development time. You will need to write this down so you will know how to process the film. Unless the light changes while you are shooting there is no need to recalculate the exposure. Try to simplify your methods as much as possible.

Q: **I can understand how the Zone System would be easy to use with a view camera where each frame is developed individually, but how can I apply these methods to roll film?**

A: Now that you are aware of the relationship between the contrast of your subject and the negative's development time, you will find yourself automatically adapting your shooting methods to ensure that the roll for each subject is developed properly. The problem most photographers have is that they are unaware that this connection exists at all. In most situations, this will not be a problem. For example, if you are shooting outdoors on a clear day, you will find that the contrast will not change very much. Take one set of readings, shoot the whole roll, and indicate on the cassette how it should be developed. If you are in the middle of a roll and you find that the contrast is changing, either because you have to change locations or because of a change in the incident light, you have two choices. You can either quickly shoot the rest of the roll and start another, or take another set of readings and make note of how much difference there is between the contrast of the two scenes. If there is less than one stop's worth of difference in contrast

(i.e., if the first scene required Normal Development and the second situation calls for N + 1), don't worry about it. Just recalculate the exposure for the second scene and count on higher or lower grades of paper to compensate for the difference. If the difference is much greater than this and you cannot change rolls, you may have to sacrifice the contrast of one scene or the other when you develop the roll or split the difference in development (i.e., if one situation required N - 1 and the other N + 1, you should develop the roll using Normal Development). A good rule of thumb for roll-film photographers is when in doubt, **overexpose and underdevelop.** It is much easier to compensate through careful printing for a slightly flat negative than for one that is too contrasty. Also, the reduced development time will minimize grain.

You will find that ingenuity and compromises are sometimes necessary when using roll-film cameras in certain situations. If you are using a camera with interchangeable backs, such as a Hasselblad, you have the option of labeling one back Normal, another N+ 1, and so on. This will allow you to switch backs as the situation demands. Eventually you will find that your awareness of the importance of subject contrast will make you very sensitive to changes in the light. Roll-film cameras are designed to make bracketing very simple. If you take advantage of this and pay attention to how the contrast changes from one moment to another, you will gradually develop instincts that will make adapting to this situation much less of a problem. Another alternative is self-rolling very short rolls of film with the intention of shooting one roll per subject. If this is done carefully (dust in the bulk loader's gate can be a serious problem), it will work and save you money. In the long run it is probably better to "waste" the extra frames on a normal roll of film. (I have put the word *waste* in quotes because often your best shots will be on those extra frames.)

Q: Can the Zone System be used with color film?
A: In general the answer is yes, and in many ways certain inherent characteristics and limitations of color films make the Zone System an even more important tool.The rules of exposure apply as much to color film as they do to black-and-white film. On the other hand, color materials present you with special problems of which you should be aware.First, the range of subject contrast that can be recorded on color reversal films (otherwise known as chrome, transparency, or slide films) is relatively narrow when compared with color negative or black-and-white films. The effective range of detail in a properly exposed and processed color negative can be between Zones II and VIII. With transparency films the range is between Zones III and VII.

Slide films are very intolerant of exposure errors (they have limited exposure latitude). If your exposure is more than one-third of a stop under the correct placement of Zone III, the whole image will be too dark. This means that in general you will get better results using color slide film in situations where the contrast is not too great; indoors with flash or outdoors on slightly overcast days, for example. The accuracy and reliability of the Zone System of exposure can be of great advantage when you are shooting color films.

The second problem is that if color film is given more or less development than the amount predetermined by the manufacturer, you run the risk of getting inaccurate color in the resulting slide or negative. Overdevelopment causes the images to look warmer (more red); underdevelopment results in cooler pictures (more blue). This shift in color balance can be corrected to some degree when color negatives are printed. Underdevelopment also causes the black areas of color slides or prints from color negatives to be "incomplete," meaning that the black areas will be rendered as a muddy dark gray with a noticeable color cast. One result of this effect is that there is no simple way to control the contrast of color films without affecting the color rendition. This means that you may have to adapt the way that you expose color film when subject contrast is greater than the effective range of the material you are using. For example, if you are shooting a very contrasty subject, a snow scene with dark foliage for instance, you may have to expose for the highlights and allow the shadows to fall where they will. This could mean metering the snow and placing the reading on Zone VII or VIII for color negatives or Zone VII for color slide films. The foliage will probably print as relatively dark silhouettes, but the overall impression of the image should be acceptable. If possible, you could use an electronic flash to add more light to the darker areas.

Color negative films are self-masking, which means that the density of the highlight areas is restrained as they develop. This essentially allows the shadows to "catch up," giving you relatively more detailed dark areas without blocked-up whites. Color negative films can be overexposed by as much as three stops and underexposed by one stop, and the negatives will still be printable. Color slide films do not have these advantages. Because of this and their more narrow contrast range, color transparency films require more careful control.

One major advantage of understanding and using the Zone System is that it gives you a reliable way of measuring subject contrast and exposing accordingly.

In commercial studio and location photography, it is often necessary to use longer or shorter development times to make small, precise corrections of the overall density and contrast of your negative or chrome. Usually Polaroid materials are used to proof setups. Contrast and exposure manipulation is done with extra lights or reflecting fill-cards. If more corrections are needed, many of the better color labs will custom process color films if you know the practical limits of the materials and how to explain what you want to the technicians.

To color labs, *pushing* and *pulling* film mean, respectively, **increasing** and **decreasing** the development time. Instead of "zones," they are more accustomed to speaking in terms of "stops." Thus "Pull this film one stop" means "Please reduce the development time of this roll by enough to give me one zone's worth of Contraction."

Following is a list of some color films and the amount of contrast control you can ask a lab to give you and still get acceptable results. *N.R.* means "Not Recommended."

FILM	ASA	PUSHING LATITUDE	PULLING LATITUDE
Kodak Elite Chrome	100	3 STOPS	N.R
Kodak Elite Chrome	200	3 STOPS	N.R
Kodak Elite Chrome	400	3 STOPS	N.R
Kodachrome	64	1 STOP	1 STOP
Ektachrome Pro	1600	2 STOPS	1 STOP
Fujichrome Velvia	50	1 STOP	1 STOP
Fujichrome Provia	100	2 STOPS	1 STOP
Fugichrome MS	100/1000	3 STOPS	N.R.
Fugicolor Super HG	1600	2 STOPS	N.R.
Vericolor III	100	2 STOPS	1 STOP
Kodacolor	100	1 STOP	N.R.

Because of the color shift problems described above, Kodak does not recommend push or pull processing for any of its Gold, Gold Max or Royal Gold color negative films.

Kodak's Ektapress films (ASA 100, 400,800 and 1600) are specifically designed to be pushed. Ektapress can very easily be pushed two stops. Special buffers are incorporated into the emulsion that enhance the self-masking effect described above. Photojournalists shooting action events routinely shoot Ektapress at twice the normal ASA, have the film push-processed, and get better results than if they had exposed and processed the film normally.

Q: What problems will I encounter if I cannot use a spot meter?

A: As you have seen in the previous chapters, a spot meter's ability to read small, isolated areas from a distance makes it the perfect tool for using the Zone System. On the other hand, you can achieve reliable results from any meter if you know how to use it properly.

A wide-angle meter will give you an accurate reading of any area if you get close enough to the metered area and are careful not to include unwanted objects in the meter's field of view.

A built-in meter, aside from being wide-angle, has two other features you should be aware of. The first is that built-in meters are very often "center-weighted," which means that they are designed to be more sensitive in the center of the frame than at the edges. Second, built-in meters are sometimes calibrated to place their meter readings on Zone VI instead of Zone V. The reason for these idiosyncrasies is that the camera manufacturer is making two assumptions. First, they are assuming that you are going to put your friends or relatives in the center of the frame. Second, the company is assuming that the subjects are Caucasian. Remember that Zone VI is the average zone for light skin.

If you are going to try using an in-camera meter in the ways described in this book, you will have to take these factors into consideration. For example, if you fill the frame of the camera with the area you are trying to meter, the fact that the meter is center-weighted will not matter. If you are metering a model's hair, this means getting close enough so that all you can see through the viewfinder is her hair. If you then center the needle or dot by adjusting the f/stop or shutter speed, you will have placed her hair on Zone VI if this is the way your meter is calibrated. (You can check your meter's calibration by comparing your readings to those of a hand-held meter or having it checked by a camera repair shop.) Let's say that the exposure the meter recommends is f/8 at 1/30 of a second. If you were to stop down three stops from this exposure, you would then have the correct Zone III exposure for her hair, f/22 at 1/30 of a second.

To measure the overall contrast of the subject, you will have to fill the frame with the Important Highlight Area, center the needle, and make note of how many stops difference there is between the shadow reading and the highlight. If the meter recommends an exposure of f/1.4 at 1/30 when you meter the shadow area and f/5.6 at 1/30 when you meter the highlight, you know that there is a four-stop difference between the two areas. Obviously, this system will work, but at best it is complex and cumbersome. If you find yourself having to do this very often, you would probably be better off investing in a decent spot meter. The 35mm camera is a specialized tool that is

designed to be quick and easy to use. With practice and an awareness of how the in-camera meter is designed, it will not take you long to develop working methods that are efficient for your shooting habits. Often you will see experienced 35mm photographers taking a meter reading from their own hands before shooting. By metering a flesh tone and making use of the meter's automatic Zone VI placement, they are using a derivative of the Zone System.

Q: How does the Zone System apply to the use of electronic flash?
A: In general, the correct exposure with electronic-flash units is calculated by carefully measuring the camera-to-subject distance with the range-finder on the lens and using this to select the proper f/stop with the exposure dial on the flash. You must use the shutter speed that is synchronized with your flash, usually 1/60 or 1/125 of a second (Check your owner's manual). As noted in an earlier chapter, with modern electronic flash units, the exposure is determined by a thyristor circuit that controls the output of the flash. Dedicated flash units automatically adjust both the f/stop and shutter speed of the camera.

The Zone System allows you to accurately measure the contrast of your subject. If you determine that the contrast is too great, you have two choices: You can base your exposure on the shadow areas and reduce the contrast of your negative by decreasing the negative's development time, or you can expose for the highlights and add more light to the shadow areas with fill-flash. This usually involves setting the flash to 1/2, 1/4, or 1/8 power depending on how much fill you need. The instructions provided with your flash will explain how this is done. The second procedure is especially useful in back-lighting situations with both black-and-white and color films.

In a photographic lighting studio where you are essentially starting with a "blank canvas," the art of previsualizing becomes an extremely important part of the overall creative process. Ordinarily studio photographers use powerful electronic strobe units with power packs to light their subjects. The lighting composition is done with built-in modeling lights that are much less bright than the flash itself. Because the bursts of light from the flash heads are extremely short, special flash meters are required to measure the incident light and provide an exposure. Since the shutter speed is fixed and synchronized with strobe, flash meters provide their readings as an aperture number. The brighter the light the smaller the aperture. It is very common for studio photographers to use Polaroid film to help them previsualize their lighting and to help calculate the exposure.

Until recently, the Zone System had no direct role in this process but modern spot-flash meters now allow you to take reflected strobe readings of the key areas of your subject. This makes the application of Zone System concepts in the studio a straightforward process. By carefully measuring the contrast of your subject you can previsualize your image and determine how much extra light to add with fill-cards or lights. Once the contrast has been balanced and adjusted your film is usually given Normal Development.

Q: Will digital photography make the Zone System obsolete?
A: The answer is no and yes. Electronic imaging techniques have changed our approaches to photography in ways that we are just beginning to comprehend. For many years it has been possible to electronically manipulate images designed for reproduction with methods so convincing that our notions of "photographic realism" no longer have conventional meanings. As profound as these changes have been, they have had relatively little effect on photographers committed to the aesthetics of the classic "fine print." The dream of many photo-artists has been that computers would provide an easy alternative to the labor-intensive multiple printing techniques perfected by Jerry Uelsmann, among others. But until recently there has been no way to use digital technology to produce manipulated continuous-toned photographic prints.

The following summary of electronic imaging processes will make clear why all of our assumptions about what was possible have changed forever.

There currently are digital and still-video camera systems that record images electronically on disks instead of on film and allow you to preview and adjust a picture's exposure and contrast before making a print. This essentially gives you an electronic Zone System. Your digitally captured images can then be transmitted or outputted to distant computers via a modem to be edited, cropped, and reproduced. This is a valuable tool for photojournalists.

For photographs taken with conventional black-and-white or color films, most electronic imaging systems begin with a device called a scanner that, depending on the system you are using, will transform a standard negative, transparency, or print into a digitized image that can be manipulated on a computer screen. As of this writing, the highest quality scans are done with drum scanners at service bureaus located in all major cities.

Once your image has been scanned into a computer file the amount of manipulation possible with software designed for this purpose is remarkable. Adobe's Photoshop is one example of a program that allows you to electronically burn and dodge the image in addition to providing an almost endless variety of other fascinating image-manipulation effects. The Zone Globe icon on the cover photograph for this book was produced this way. It is even possible through a process called "cloning" to correct even seriously underexposed or overdeveloped areas of your image by either "cloning" detail into those areas of the picture from other images, or, if you have the skill, actually painting in the texture you want to see. Of course, the less photographic information present in the original negative, transparency, or print, the less there is to work with. Ideally you would begin with a properly exposed and developed original as the point of departure for your final image. Understanding the Zone System is a great advantage in achieving the best results.

Once you have achieved the image you want on the computer screen, the problem is how to create an acceptable final print. It has long been relatively easy to produce half-tone negatives or color separations from computer files for standard offset reproduction, but until recently the image quality these systems produced was relatively poor when compared with standard photographic prints. A number of technological breakthroughs have radically changed all of this, and in the process, have caused many of us to take digital images much more seriously than ever before. First, sophisticated ink-jet or thermal dye transfer printers can reproduce near-photograph-quality images on a wide variety of paper surfaces. The Iris printer and the various near-continuous-tone printers are examples of this technology. Small high-resolution ink-jet printers are now very inexpensive. The second option would be to take your photograph, which at this point is stored in digital form on your portable hard disk cartridge, to a service bureau. Using a digital film recorder, technicians can produce an actual photographic negative or transparency that you can print with a standard enlarger.

Many people own personal computers with hard drives and high-resolution monitors capable of utilizing the now-standard image-manipulation programs, but drum scanners and large-scale printers that can read and reproduce digitized images of the highest quality are still too expensive for most individuals to own. There are also fundamental limitations to the degree of image quality that these systems can produce. For example, most digital systems (8 bit) are only capable of reproducing 256 steps of tone per color, that is, 256 tones of gray for a black-and-white image versus 16.8 million tones for a full-color

image. This number of tones will seem like a lot until you carefully compare it to the nearly infinite tonal variations of a full-scale black-and-white print.

Regardless of what new technologies emerge, it's unlikely that photographers will stop using traditional methods entirely. Even today many artists still draw with charcoal sticks on paper, or with waxy crayons on stone. There remain aesthetic qualities that cannot be achieved in any other way. The same is true for photographers and will no doubt remain so for quite a while.

One interesting hybrid of old and new technologies is the work of photographers like Dan Burkholder who photograph with conventional films and then scan their negatives to produce digital files they can manipulate with Adobe Photoshop on desktop computers. It is then possible to output what are called bit-mapped negatives that can be printed on hand-coated or commercial platinum papers. The ability to precisely manipulate the contrast of the enlarged negatives greatly facilitates the process of printing on papers with non-silver emulsions. The results are exquisite and suggest the many creative possibilities of this new medium. An example of Dan's work is included in Appendix N on page 157.

What all of this means is that while some of the image control and image enhancement functions of the Zone System can be duplicated using digital technologies there are some inherent limitations and unique characteristics to these processes that make them an entirely new visual language. The Zone System will always be a valuable tool for photographers who are generating their own images for whom quality and efficiency are important.

Q: How can I override my camera's automatic metering system?

A: As we discussed earlier, most built-in light meters are designed to operate "automatically," which means that when you adjust one of the exposure controls, the meter will internally adjust the other to maintain its recommended Zone V exposure. There are two types of built-in meters.

Aperture-priority meters allow you to choose the aperture you prefer and the meter will adjust the shutter speed.

Shutter-priority meters allow you to choose the shutter speed you prefer, and the meter will adjust the aperture.

In order to use an exposure other than the one recommended by the meter, you will have to override these automatic functions using one of the following methods, depending on how your camera is designed (check your owner's manual).

Manual Setting. If your camera has a manual mode, you can set both the aperture and shutter speed to the exposure of your choice. For example, if the meter recommends an exposure of f/11 at 1/30 for an area you wish to print as Zone III, you can simply change your setting to either f/22 at 1/30, or f/11 at 1/125. These exposures are equivalent and are both two stops darker than the meter's recommended setting (Zone V).

Exposure Compensation Dial. This function allows you to change the meter's recommended exposure by up to three stops darker (- 1, -2, -3), or one to three stops lighter (+1, +2, +3). Some cameras use (x 1/2, x 1/4) for darker exposures and (x 2, x 4) for lighter exposures. Refer to Appendix I if the use of these exposure factors is not clear.

Memory Lock. This function allows you to take a meter reading of a given area of the scene, lock that recommended exposure into the meter, step back, and use this exposure for the whole picture. Because the meter's recommended exposure is Zone V, this means finding a part of the subject that you previsualize as middle gray in the final print and locking in the recommended exposure for that area. Some photographers carry a Neutral Gray Card with them to use in situations like this. A variation on this procedure would be to meter an area you previsualize as Zone III and stop down two stops from the meter's recommended exposure.

Film Speed Adjustment. If your camera has no other way of overriding its automatic function, it is usually possible to change the meter's recommended exposure by resetting the ISO/ASA. Remember that when ASA numbers double (for example, from ASA 400 to 800), the amount of exposure required halves. Halving your ASA setting will increase the exposure by one stop. Review "Measuring Zones," page 38, Chapter 4. For example, imagine that you are metering a wall and your camera recommends f/16 at 1/60 for a film rated ASA 400. That exposure would render the wall Zone V. To place the wall on Zone IV, change the ASA from 400 to 800. The recommended exposure would then be f/22 at 1/60 or equivalent. To place the wall on Zone VI, change the ASA from 400 to 200. The recommended exposure would then be f/11 at 1/60 or equivalent. Remember to reset the ASA to your normal speed for that film after taking the picture.

There are cameras with DX code-reading systems that automatically set the ASA for you, and there are some "fully automatic" cameras that do not allow you to override the metering system. The Zone System cannot be effectively used with these cameras.

Q: What role do ASAs play in applying the Zone System to my photography?

A: Most photographers think of ASA as simply a rating of a given film's sensitivity. This is true as far as it goes, but there is more to it than that. Earlier I said that ASA numbers can be related to f/stops and shutter speeds in the following way: As the ASA number gets *smaller*, the amount of exposure needed *increases*. Keeping in mind that the amount of exposure determines the negative's *shadow density*, we can state the above rule in another way: **The lower the ASA number you use for a given film, the more density and detail you will get in the shadow areas of your negatives and prints.**

Taking this into account, you can see that the important question is "What ASA should I use with my film to get the best shadow detail?" Many photographers have discovered from experience that the manufacturer's recommended ASA does not give them the amount of shadow detail they need in their work. In other words, after carefully placing a shadow reading on Zone III using ASA 400, you may find that the negative is underexposed by one stop (Zone II). This is not because the placement is incorrect, but rather because the photographer overestimated the speed of the film. The remedy is to shoot the film at ASA 200 instead. This would give the film one stop more exposure every time and guarantee that Zone III will always print with the detail you expect.

There are, of course, many situations where you need to use a *higher* ASA than the manufacturer recommends. This is called *pushing* the film, and it is often necessary in low-light situations. Do this with films that are relatively fast, such as Kodak Tri-X or Ilford HP-5 Plus. Faster films generally have more exposure latitude than slower films. The only way to determine what ASA will suit your needs is to test your film and developer.

I should make one last point about the effect of changing a film's ASA. Using a lower ASA will improve your shadow detail, but it will also add density to the highlight areas of the negative. To compensate for this, you must establish a Normal Development Time that is shorter than the manufacturer recommends. The reverse is also true. If you push the ASA of a film, you must increase the film's Normal Development Time.

Q: How do I know what the Normal Development Time is for the film and developer I use?

A: Film and developer manufacturers routinely recommend a range of standard development times for their products. These are useful as starting points, but you cannot depend on them for reliable results. The problem is that the correct Normal Development Time for your needs depends on a number of variables, including the following:

1. The ASA you use.
2. The rate of agitation you use while developing the film.
3. The dilution and temperature of the developer.
4. The grade of paper you routinely use.
5. Whether you use a condenser- or diffusion-type enlarger (See Appendix E).
6. The pH of the water in your area.

Even if you try to follow the manufacturer's instructions exactly, your times could still be different than those they recommend. The only way to determine the Normal, Expansion, and Contraction development times that are correct for your photography is to do a test with your camera and meter that takes all these factors into consideration. The following two chapters outline two testing methods for this purpose.

CHAPTER 8
Zone System Testing: Method 1

INTRODUCTION

In the hands of serious photographers, the Zone System can be a power-ful, creative tool. Zone System testing is important because it provides you with valuable information and demonstrates that your camera, film, and light meter can work together in a direct and systematic way.

Unfortunately, my experience has been that some students become frus-trated and give up in their efforts to master the system when confronted with the need to test their equipment and film. The problem is that most testing procedures are too abstract or complex. Of course, a certain amount of discipline and persistence are required to complete any test, but photographing gray cards under floodlights or plotting curves on graphs is only going to excite photographers who enjoy working scientifi-cally. Most of us would rather just take what we have learned directly into the world and begin using it.

The main difference between the testing method outlined in this chapter and others is that it allows you to work directly with all the problems and variables you will encounter in your work. In one sense, this makes the test more difficult. In a studio, you do not have to worry about clouds, changing light, or all the other factors that are so much a part of photogra-phy in the outside world. The advantage of this approach is that a test of this kind saves you from having to do one test in the studio and another in the field to see whether your laboratory results really work. For a pho-tographer with the necessary time and patience, a test of this sort will yield a wealth of information and confidence. The finished print will be tangible proof of your ability to control exposure and development.

This book offers two approaches to Zone System testing. In different ways each method allows you to begin applying the Zone System to real-life shooting situations right away. Method 1, in this chapter, is adapted from a number of the more classic methods outlined in other works on this subject. This test is designed to give you the maximum amount of information with the minimum amount of time and film. Zone System testing Method 2 in the next chapter is designed for experienced photographers who would like reliable guidelines as starting points for determining their personal working ASA, Normal Development, Expansion, and Contraction times. Whichever method you use, it is important that you read the procedure through completely and make sure that you understand it before you start. It is also a good idea to work through this test with a friend to help you record and organize the steps.

Appendix K, the Zone System Testing Checklist and Exposure Record, will help you keep track of your procedure and record your results. Instructions for sheet-film users are enclosed in boxes. Make as many copies of the Exposure Record as you will need for each test you do.

Having done this test with dozens of students, I can confidently say that your results should be within predictable limits. (See the development charts for method 2 in Chapter 9.) In a sense, you are not testing the materials so much as your ability to make your equipment, film, and processing procedures respond as they should. If you finish Method 1 with unreasonable results (for example, ASA 1000 or 50 for Tri-X), you have definitely done something wrong. If this happens, review each step carefully until you are sure you understand where the problem is, then start again.

Instructions are included for testing both roll and sheet film. The results from these tests will apply only to films with ASA ratings equal to the film you are testing. Method 2 lists a number of different films and the results obtained from testing them for Normal, Normal Plus, and Normal Minus times. Using these charts as a reference, it is possible to extrapolate the results from one film to another with a different ASA, but this requires a great deal of experience. In general, I would recommend that new Zone System users retest when they change films or developers.

CHOOSING A PHOTOGRAPHIC PAPER

Although paper grade or variable contrast filter 2 is standard for Normal contrast negatives, experienced photographers know that every brand and grade of paper has unique characteristics. One of the objects of Zone System testing is to match the contrast of your negatives to your favorite type and grade of printing paper. Having standardized your normal printing, you can use the higher and lower paper grades when extreme Expansions or Contractions are required to compensate for very low or high contrast subjects.

For those who have not decided what paper to use for this test, I recommend that you begin researching the range of different paper surfaces and tones that are available by comparing the paper sample books available at most photographic supply stores.

No one brand or type of paper is ideal for all uses, but in general, the more expensive graded or variable contrast fiber-based papers are preferred for exhibition-quality printing. Resin-coated papers are ideal for volume production printing because they process much more quickly and require much less washing and drying.

> **Note:** In the previous edition of this book I wrote, "...in general, resin-coated papers are not recommended for exhibition-quality work because they have not been proven to be archival." But then my favorite Kodak representative pointed out to me that the same resins are used for both RC papers and the bases of Kodak films. Color printing papers are also all resin-coated.

An important factor to consider when choosing a personal Normal grade of paper is the light source of your enlarger. Condenser enlarging light is inherently more contrasty than light from cold-light or diffusion enlargers. This means that you will generally use lower paper grades when printing with condenser enlargers. For more information on this factor see Appendix F.

THE USE OF EQUIVALENT ASA NUMBERS

Testing Method 1 is designed to allow you to test your film at a wide range of ASA numbers on the same roll or box of film. In this way, you will determine which ASA is best for your purposes. To do this, you are going to bracket your exposures on each roll according to a predetermined plan. The principle that governs this process is very simple. **Bracketing your exposures is the same as changing the ASA on your meter.** Consider this demonstration:

1. Set your light meter to ASA 400 and place meter number 12 opposite the Zone V arrow. If you were testing Tri-X, normally rated ASA 400, and had placed meter number 10 on Zone III, your first exposure would be **f/16 at 1/60 of a second** (Figure 54).

Figure 54: *Zone III placement of meter number 10 at ASA 400.*
Exposure: **f/16 at 1/60 of a second.**

2. Stop down one-half stop from this starting point without changing your ASA. Your exposure is now **1/60 of a second at f/16-22** (Figure 55).

Figure 55: *One-half stop less exposure at ASA 400.*
Exposure: **f/16-22 at 1/60 of a second.**

3. If instead of stopping down, you were to reset your ASA to 600 without changing your placement of meter number 10 on Zone III, the result would also be **1/60 of a second at f/16- 22** (Figure 56).

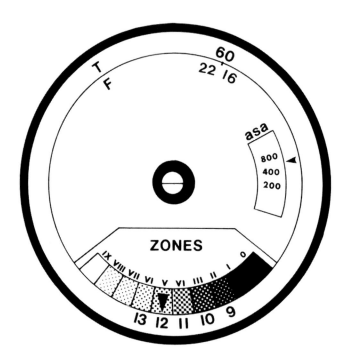

Figure 56: Zone III placement of meter number 10 at ASA 600 (between ASA 800 and 400). Exposure: **1/60 of a second at f/16-22**.

These examples demonstrate that after you have established your placement of the Important Shadow Area, stopping down has the same effect as shooting at a higher ASA number. As far as the film is concerned, there is no difference. Of course, this principle also operates in the other direction: Opening up is the same as using a lower ASA number.

In testing method 1, you will be filling in a column on the Exposure Record labeled "ASA" (column C in Figure 58). The ASA numbers that you enter in this column will be the ASA numbers that are equivalent to the exposures in the adjacent columns. For example, Figure 56 shows that ASA 600 is equivalent to stopping down one-half stop from f/16 at 1/60 of a second at ASA 400. **At no point in the test should you change the ASA setting on the dial of your meter.** Set your ASA dial to the number recommended by the manufacturer, then stop down or open up as indicated by the exposure plan that is appropriate for your film format. After you have calculated and entered your exposures on the Exposure Record, enter the equivalent ASA numbers in the column to the right.

This process will be reviewed here, but it may be useful for you to work with this concept using your meter dial until it is clear.

ZONE SYSTEM TESTING METHOD 1

This test has three objectives:

1. To establish a **personal working ASA** (also called your Exposure Index, or EI) for whatever film and developer you decide to use. What you are trying to find is the **highest** ASA for your film that will give the **best shadow detail in your negatives and prints**. The result of this test may be a different ASA than the manufacturer recommends, but once it is established, it will be a standard you can depend on for good results.
2. To determine your **Normal Development Time**. This is the time you will use for subjects with Normal contrast. It will also be the basis for your Expansion and Contraction development times.
3. To determine a **standard printing time.** Whenever you make a print, there is a minimum amount of exposure under the enlarger at a given f/stop that will make the clearest part of the negative (Zone 0) as black as it can get. Let's say this exposure time is twenty-two seconds. If twenty-two seconds is truly the minimum time it takes to make the film base as black as it will print, then twenty-four seconds (or for that matter five hundred seconds) will not make Zone 0 any darker. What the extra exposure would do is make all the other tones in the print darker. Any less exposure will not be enough to give you a true black anywhere in the print.

A simple test outlined in this chapter will determine your minimum time for maximum black exposure, which you will use as a standard for the test. Because this time will change when the enlarger is focused higher or lower, you must also choose a standard image size. Your test results will apply regardless of what size print you decide to make in the future.

For this test, you will need the following materials:

1. A camera, tripod, and cable release. Test your camera for light leaks and shutter accuracy before you start.
2. A reflected-light meter. A spot meter is preferable because it is easier to get an accurate and consistent reading. Whatever light meter you use, be sure that it is accurate or that you know how to compensate for it if it is not. See Appendix I.

3. Film. I have included instructions for testing both sheet and roll film. If you are doing this test with roll film, you will need four rolls of your favorite film. For sheet-film testing, you will need twenty-four sheets. After you have loaded your twelve film holders, divide them into four sets with three holders (each containing two sheets) in each set, and label them A, B, C, and D. Number each set from 1 to 6. This will give you four number 1 sheets (1A, 1B, 1C, 1D), four number 2 sheets, and so on.

Figure 57: Sheet -film holder arrangement. Sets C and D are not shown.

4. Developer. You will need enough of your favorite developer to process the film required. Be sure you dilute the developer and control the temperature very carefully. It is important that the temperatures of the developer, stop bath, and fixer are all the same. For more information about developers and films, consult Appendix A and testing Method 2.

5. Photographic paper. Use a normal grade of paper. Grade 2 is normal for most brands. Check the manufacturer's information sheet if you are not sure. If you prefer a particular type or grade of paper, you can use it if you keep in mind that this will become your standard paper for as long as you use the same film and developer. (See Appendix F for information on the role different enlarging light sources play in choosing a Normal grade of paper).

6. A Neutral Gray Card. This will provide a visual reference in the printing part of this test.

7. If you are testing sheet film, you will also need a large note pad and marker.

8. Last, but not least, you must select an appropriate test subject. For reasons discussed earlier, you should do this test outdoors or under your normal working conditions. A light-colored house makes an ideal subject because it is usually easy to meter a full range of zones, from Zones II and III for dark shrubs or woodwork to Zones VII and VIII for the house itself. If it is a clear day or slightly overcast, the contrast will remain constant for a reasonable amount of time. On partly cloudy days, the light is too unstable. If you choose not to use a house, any subject that gives you a full range of zones will do.

Whatever subject you choose, it is important that you have clearly visible and *logical* areas of Zones II, III, and VII. I emphasize the word "logical" because in the end, it is your judgment of the final print that will determine the results of this test. The goal is to end up with a beautiful, full-toned rendering of the test subject. If you keep careful records of how you make this print (the ASA, placement, and development time), you will have established these as standards for future use.

Careless previsualization can throw off the whole process. For example, if you choose the darkest part of the subject (logically Zone I) as your Important Shadow Area, you might succeed in rendering that area as Zone III in your print, but your negative will be overexposed by two stops, and this will give you misleading results.

It is also important that the subject you choose has Normal contrast. If the test subject is too flat or too contrasty, it will confuse you unnecessarily. Many of my students are casual at this point and it ruins their results. The time you spend finding the perfect subject will be well worth it in the end.

Begin by making a simple form like the one in Figure 58 or make an enlarged copy of the Exposure Record on page 139. Use a copy of the checklist on pages 140-141 to keep track of your progress.

FILM:		ZONES									A	B	C	
SUBJECT	O	I	II	III	IV	V	VI	VII	VIII	IX	S SPEED	F STOP	ASA	DEV
1														
2														
3														
4														
5														
6														
7														
8														
9														
10														
11														

Figure 58: Exposure Record.

Step 1

Assuming that you are using a house for this test, make a simple sketch of it above your form (Figure 59). It does not have to be detailed as long as it outlines all the important areas you are reading.

FILM:				ZONES								A	B	C	
SUBJECT	O	I	II	III	IV	V	VI	VII	VIII	IX	S SPEED	F STOP	ASA	DEV	
1															
2															
3															
4															
5															
6															
7															
8															
9															
10															
11															

Figure 59: Step 1 – Sketch and Exposure Record.

Step 2

Carefully meter all the important shadow, middle, and highlight areas of the house, and write the meter numbers on the sketch (Figure 60). Try to record as many numbers as you can. You will have to check these readings often throughout this test to make sure they do not change. Again, make sure your subject has prominent areas of Zones II, III, V, and VII (and Zone VIII if possible).

SUBJECT	ZONES										A	B	C	
	O	I	II	III	IV	V	VI	VII	VIII	IX	S SPEED	F STOP	ASA	DEV
1														
2														
3														
4														
5														
6														
7														
8														
9														
10														
11														

FILM:

Figure 60: Step 2 – Sketch with meter readings.

Step 3

Place the meter readings from the house on the Zone Scale according to your previsualization (Figure 61).

Remember that one of the primary objectives of this test is to determine your Normal Development Time. For this reason, it is very important that your placements be logical and that all the values fit properly on the scale. For example, a common mistake would be to place the meter reading for the very dark part of the subject on Zone III instead of Zone II. This would result in a print that looks one stop lighter in the shadow areas than you would expect. **Zone III is the appropriate zone for well-lit, fully textured, dark subject areas such as green foliage and brown wooden doors**. Also, if the contrast of your test subject is too flat or too contrasty-in other words, if the Important Highlight Area falls on Zone VI or VIII instead of Zone VII, find a better house.

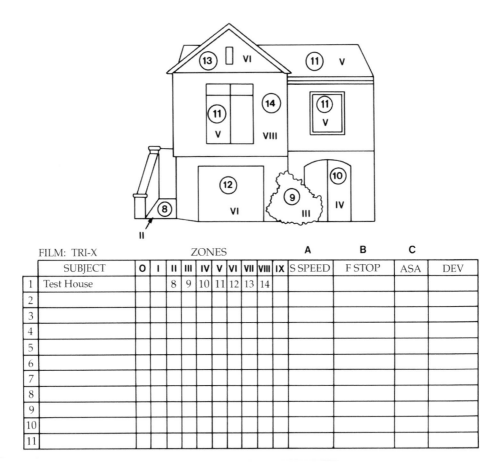

FILM: TRI-X						ZONES						A	B	C	
SUBJECT	O	I	II	III	IV	V	VI	VII	VIII	IX	S SPEED	F STOP	ASA	DEV	
1 Test House			8	9	10	11	12	13	14						
2															
3															
4															
5															
6															
7															
8															
9															
10															
11															

Figure 61: *Step 3 — Sketch and Exposure Record with placements.*

> **Note:** Do not be surprised if all your meter readings do not fit as perfectly on your Zone Scale as they do on my ideal illustration. If, for example, after placing your Important Shadow Area on Zone III, the area that you wanted to be Zone VI falls on Zone VI 1/2, simply record this on the Exposure Record and take this into consideration when you evaluate your final test print. What is important is that you have clearly visible areas of Zones II, III, and VII.

Step 4

Set up your camera and put the Neutral Gray Card in the picture in a place where it reads Zone V. Remember that although the card itself is Zone V, if it is put in a dark area of the scene, it could fall on Zone III or IV. Keep moving it around until its meter reading falls on Zone V.

Step 5

Calculate your exposures and fill in the blank spaces of your Exposure Record using the following procedure. You will expose the first frame of your test roll or the number 1 sheets of your four sets of film using the manufacturer's recommended ASA. The exposures of the remaining frames will be bracketed by half stops for one or two full stops in both directions from this starting point. As explained in the introduction, bracketing exposures has the same effect as changing the ASA.

Under column A, labeled "S Speed," list the shutter speed chosen for your test exposures. For greater accuracy, it is important that you bracket using the f/stops rather than the shutter speeds. Choose a shutter speed that allows you a two-stop range of apertures on either side of the starting point for roll-film tests and one stop above and below for sheet film.

Under column B, labeled "F/Stop," list the apertures of your test exposures using the formulas listed below. Use plan A for roll-film tests and plan B for sheet-film tests.

> **Note:** You will expose the first frames of your test rolls and sheets using the aperture recommended when the meter is set at the standard ASA for the film being used. Thereafter, you will adjust your exposure by half stops in both directions from this starting point without changing the ASA on the meter's dial. Only the aperture should be changed during these test exposures.

EXPOSURE PLAN A FOR ROLL FILM

Expose your test rolls as follows:

FRAME	APERTURE SETTING
1	Normal exposure at the film's standard ASA
2	One-half stop less exposure than frame 1
3	One full stop less exposure than frame 1
4	One and one-half stops less exposure than frame 1
5	Two full stops less exposure than frame 1
6	Same exposure as frame 1
7	One-half stop more exposure than frame 1
8	One full stop more exposure than frame 1
9	One and one-half stops more exposure than frame 1
10	Two full stops more exposure than frame 1
11	Blank
To end	One full stop more exposure than frame 1

EXPOSURE PLAN B FOR SHEET FILM

Expose the sheets labeled 1-5 of sets A, B, C, and D as follows:

SHEET	APERTURE SETTING
1 (A, B, C, D)	Normal exposure at the film's standard ASA
2 (A, B, C, D)	One-half stop less exposure than sheet 1
3 (A, B, C, D)	One full stop less exposure than sheet 1
4 (A, B, C, D)	One-half stop more exposure than sheet 1
5 (A, B, C, D)	One full stop more exposure than sheet 1

Under column C, labeled "ASA," list the equivalent ASA numbers for the exposures listed in columns A and B.

> **Note:** Modern light meters list ASA numbers that double from 6 through 6400, with one-third-stop markings in between. For the purposes of this test, we are bracketing by half stops. Use equivalent ASA numbers that are halfway between these printed numbers. For example, between ASA 400 and ASA 200 would be ASA 300 or 250. The actual number you use does not matter as much as being consistent. Of course, your meter numbers and exposures will probably be different, but at this point, your Exposure Record and sketch should be similar to Figure 62. Study this illustration carefully. It is important that the logic of these settings is clear.

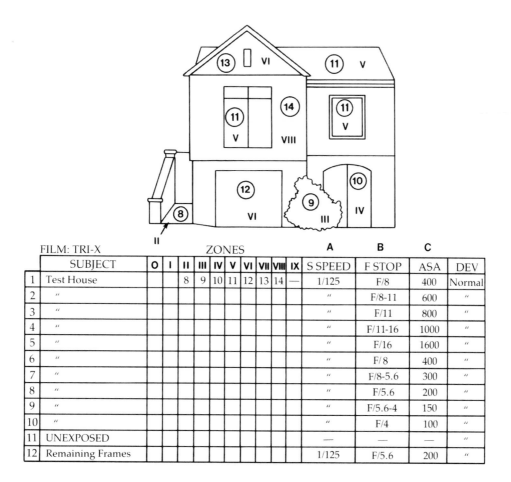

| FILM: TRI-X | | | | | | ZONES | | | | | A | B | C | |
SUBJECT	O	I	II	III	IV	V	VI	VII	VIII	IX	S SPEED	F STOP	ASA	DEV
1 Test House			8	9	10	11	12	13	14	—	1/125	F/8	400	Normal
2 "											"	F/8-11	600	"
3 "											"	F/11	800	"
4 "											"	F/11-16	1000	"
5 "											"	F/16	1600	"
6 "											"	F/8	400	"
7 "											"	F/8-5.6	300	"
8 "											"	F/5.6	200	"
9 "											"	F/5.6-4	150	"
10 "											"	F/4	100	"
11 UNEXPOSED											—	—	—	"
12 Remaining Frames											1/125	F/5.6	200	"

Figure 62: Step 5 — Sketch and Exposure Record filled in completely.

Step 6

Recheck the key meter readings of your test subject to make sure the light has not changed. (It will take you much less time to actually meter your subject and fill in the Exposure Record than it took you to read through the previous step.)

Step 7

Roll Film

Expose the first roll of film using the exposures listed on the Exposure Record. Use your lens cap for the blank frame on each roll. The remaining frames are exposed in order to keep the number of exposed frames being developed consistent with your usual procedures.
 Expose the remaining three rolls exactly the same way, making sure the light has not changed between rolls or exposures.

Sheet Film

Using the exposures listed on the Exposure Record, expose the four sets of film holders according to the following procedure. This will ensure that the exposures of all four sets are identical. It will also help you identify each sheet for future reference.

 a. Put your large pad in the test area in a clearly visible place. The writing on this pad will be easier to read in the test prints if you avoid putting it in a brightly lit area of the scene.
 b. In large letters, write "1A" on the pad, then expose sheet 1 of set A as listed on your Exposure Record.
 c. Write "1B" on the notepad and then expose sheet 1 of set B using the same exposure you used for sheet 1A. Label sheet 1 of sets C and D on the note pad and give them the same exposure.
 d. After stopping down one-half stop as listed on the Exposure Record, label and expose sheet 2 of sets A, B, C, and D.
 e. Follow the same procedure to expose and label the rest of the sheets in each set.

> **Note:** The idea is to expose and label all sheet number 2 exposures according to their sets *before* you stop down and expose the number 3 sheets. In this way, you can be sure all the sheets of the same number have the *same exposure*. By looking at the number on the pad, you will also be able to tell which negative you are working with.

Step 8

After you have exposed all your film, develop one roll or one complete set of sheet film (1A-5A plus one sheet of unexposed film), using your favorite developer. If you have a Normal Development Time you are comfortable with, use it. If not, use a time I recommend in testing method 2 in Chapter 9 or refer to the fact sheet that came with the developer. Use the *minimum* time recommended for your film. Process and dry your film normally.

Step 9

Standard Printing Time (SPT) Test

To determine the *minimum* time it takes to achieve the *maximum* black, perform the standard printing time (SPT) test as follows:

1. Using one of your test exposures, focus your enlarger at the printing size that is normal for your work.
2. Place the blank sheet of film in the negative carrier so the unexposed film covers one-half of the opening. To do this with roll film, you must cut the blank frame in half. Your negative carrier should look like this:

Figure 63: Negative carrier with film base.

3. Put the negative carrier in the enlarger and make a series of test exposures on a full sheet of normal paper at two-second intervals. Use an f/stop that is in the middle of your enlarger's range and try to get as many exposures on the test sheet as possible.

4. Develop the print for two to three minutes in your normal print developer. When this print is processed and dried it should look like Figure 64.

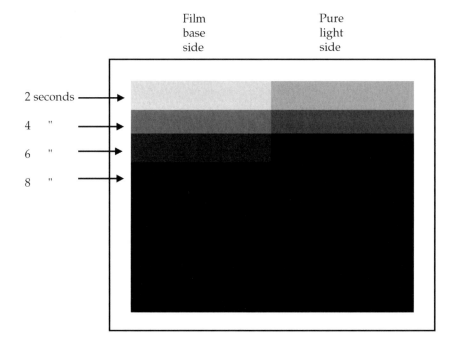

***Figure 64**: Test print.*

If the division between the two halves of this print does not disappear somewhere along the sheet, you have not reached the paper's maximum black exposure time. Open up one stop and make another set of exposures.

> **Note:** You may notice a very faint line between the two halves of this print. Just ignore this.
>
> It is important that your test print be dry before you go on to the next step. Most printing papers darken as they dry, and this will affect your judgment of which step is truly black.

5. Count the exposures on the *film-base* side of the print until you can no longer see the difference between one step and another. The first completely black step on the *film-base* side of the test print represents the exposure time you are looking for. If this step equals eight seconds' worth of exposure, your standard printing time is eight seconds at whatever f/stop the lens is set. Note this exposure for future use.

> **Note:** The steps on the "pure-light" side of the print should already be totally black. Use these for comparison.

Step 10

Make one straight print of each test frame on a normal grade of paper using your new SPT. If you are testing roll film, remember to write the frame number on the back of each print. This number is the key to the ASA that was used to expose that frame.

Process and dry these prints before you judge them.

Step 11

If you are testing roll film, you should now have ten prints of the test subject. Sheet-film testers should have five test prints. Each print should be a little lighter or darker than the next because the prints represent exposures at different ASA numbers. Arrange these prints in the order that you exposed them. If you have done everything correctly, they should appear as follows:

Roll Film

Print 5 should be the darkest.
Print 7 should be lighter than print 1.
Print 9 should be the lightest.

Sheet Film

Print 3A should be the darkest.
Print 4A should be lighter than print 1A.
Print 5A should be the lightest.

Step 12

The next step of this test is judging your test prints. Before you begin, it is important for you to know that it is very easy to choose an SPT that is slightly too long. This can be due to your timer being inaccurate or to the fact that printing papers do not always respond logically to accumulating amounts of light. Five two-second exposures might not produce the same effect as one ten-second exposure. Choosing an SPT that is **too long** will cause you to choose an ASA that is **too low.** When you get to the point of selecting one print over another, keep this factor in mind. When in doubt, always try a slightly shorter SPT to print your key negative.

You can ignore the test prints that are obviously too light or dark, but two or perhaps three prints should have well-exposed shadow values. At this point, the shadow areas are the only parts of the print in which you are interested. (The highlights of these prints may be too gray or too white, but for now they are not important.)

Looking only at the darker parts of the image, choose the print that in your opinion has the best detail in the shadow areas. The Zone II areas of the print you select should be dark with a trace of detail. The Zone III areas should have good contrast and be **fully detailed**. Your sketch (Figure 62) will remind you of where these areas are. With this in mind, you should be able to narrow your choice to two prints. Remember that the goal of this test is to find the **highest ASA that will give you the best shadow detail in the Zone II and III areas of your prints.** If, for example, you are testing Tri-X and the prints representing ASA 300 and ASA 200 both appear to have good shadows, consider ASA 300 your choice. If the ASA 300 print has shadows that are a little too dark, make another print of this negative at a slightly shorter SPT and see whether it is acceptable.

If the shadows of the ASA 300 print are acceptable but the highlights are much too light, choose the ASA 200 print instead. The reason is that step 13 involves correcting the development time of your key negative. If the ASA 300 negative has good shadow detail but requires a reduction in the highlights, shortening the development time may reduce the shadow densities below a usable limit. If this is the case, the extra density in the shadow areas of the ASA 200 negative will give you a little leeway. Using this line of reasoning, you should be able to select the correct ASA for whatever film you are using. Having done this, you are now interested in only one key frame or one sheet of your test rolls or sets.

Do not be surprised if the print you choose represents an ASA that is lower than the manufacturer recommends. This is very common. On the other hand, if you end up with an ASA that is unrealistically high or low (for example, ASA 150 or 600 for Tri-X), you have probably made a mis-

take. Once again, the first thing to check is the SPT. Another common mistake is choosing an illogical area for Zone III. Consider your previsualization very carefully before you make your exposures. Placing the shadow on the wrong zone will throw off your judgment at this stage of the test.

Step 13

The last step of this test is judging the highlights of your key print. The procedure for this part of the test is to increase or decrease the development time of your duplicate test rolls or sets until you find the exact time that will allow your key frame to print well on a normal grade of paper. This will work only if the contrast of the test subject was Normal to begin with.

Refer to your sketch to see which areas fell on Zone VII. If the Zone VII areas of the print you selected for the best shadow values (again, refer to your sketch) are light gray and detailed to your satisfaction, then the amount of time you developed that negative is your new Normal Development Time. Congratulations! If the highlights of your key print are **too dark,** develop your second roll for **20 percent more time** than you developed the first roll.

> **Note:** Increasing the development time will slightly increase the density of the negative's film base. For this reason, a slightly longer SPT may be needed to keep the shadows from printing too light. If an extreme increase in the development time is required, you may be able to move to the next higher ASA number.

Sheet-film users should develop all six sheets of set B in spite of the fact that you are interested in only one key frame. It is important that you keep constant the number of sheets being developed in a given quantity of developer.

If the highlights of your test print are **too white,** develop set B or your second roll of film for **10 percent less time** than the first set. Make a print of the key frame.

At this point, you should be very close to having a perfect print. If for some reason you are still not satisfied with your results, you still have two identical sets of test film with which to work. By continuing this process, you will eventually end up with a good print that will embody your new working ASA and Normal Development Time. These will apply whenever you use that combination of film and developer to make prints of any size.

Expansion and Contraction
Development Times

The following formulas will give you a shortcut method of computing your Normal Plus and Normal Minus Development times. A pocket calculator will make these computations very simple. Notice that special procedures are necessary to achieve good results with Expansions or Contractions of more than N+2 or N-2. Refer to Appendix B for more information on extreme Expansion and Contraction development and the use of compensating developers.

Note: You will probably have to adjust the development times that you derive from these formulas as you go along. Keep careful records of your results.

Standard Films

Normal Minus
To determine your Normal Minus Development times, start with your new Normal Development Time and follow this procedure:

> For your N-1 time, multiply your new Normal time by 0.7.
> For your N-2 time, multiply your new Normal time by 0.6.

For example, if your new Normal Development Time is ten minutes, your N-1 time would be seven minutes, and your N-2 would be six minutes.

Normal Plus
To determine your Normal Plus Development times, the procedure is slightly different.

> For your N + 1 time, multiply your new Normal time by 1.4.
> For your N +2 time, multiply your new N + 1 time by 1.4.

For example, if your new Normal Development Time is ten minutes, your N + 1 time would be fourteen minutes, and your N + 2 time would be 19 1/2 minutes.

T-Grain Films

Because T-Grain films are unusually responsive to changes in development time, the Expansion and Contraction formulas listed above do not apply to these films. When processing T-Max or Delta films in the standard dilutions of most developers, use the following formulas to compute your Normal Plus and Normal Minus times.

Normal Minus

To determine your Normal Minus Development times when using T-Grain films, start with your Normal time and apply the following formulas:

> For your N-1 time, multiply your Normal time by 0.9.
> For your N-2 time, multiply your Normal time by 0.8.

Normal Plus

To determine your Normal Plus Development times when using T-Grain films, apply the following formulas:

> For your N + 1 time, multiply your Normal time by 1.1.
> For your N +2 time, multiply your N + 1 time by 1.1.

Note: The times you derive from these formulas should only be considered as starting points for determining the exact Expansion and Contraction times for your development procedures. Keep careful records of your results.

CHAPTER 9
Zone System Testing: Method 2

The experience and information that you can gain from completing Zone System testing method 1, described in the previous chapter, can be extremely useful. On the other hand, there are many good reasons why you may decide not to begin such a long procedure. You may for example already be confident that you know how the Zone System works, or you may simply not have the time required to run a complete test. The problem is that you will still need a reliable ASA and Normal Development Time in order to effectively apply the Zone System to your photography.

Testing Method 2, described here, is very simple. The first step is to choose your film and to begin photographing using the ASAs and Normal Development Times that I suggest in the charts on pages 112-117. A wide variety of films and developers are listed there. If your favorites are not listed, you will have to extrapolate my times to suit your needs. Normal Plus and Normal Minus Development times are also provided to give you all the information you will need to get started.

> **Note:** If you are not familiar with the films and developers in these tables or simply need more information, consult Appendix A, "Films, Developers, and Processing," for a comprehensive survey of the materials used in these tests.

The second step is to keep a careful "diary" of your results and use this to modify and perfect your standards. A typical notation in your darkroom diary might look like this:

DATE	FILM	ASA	DEVELOPER	CONTRAST	TIME	RESULT
11/22	Tri-X	250	HC-110 (D.B)	N-1	4 min.	N-1 1/2

Assuming that your metering and placement were correct, this entry would mean that this negative needed a one-zone reduction in contrast (Contrast = N - 1). Developing it in HC-1 10 dilution B for four minutes reduced the contrast by1 1/2 zones. In other words, when you printed this negative on a normal grade of paper, the highlights were generally *grayer* than you wanted them to be. The result indicates that four minutes is *too short a time for an N - 1 development in HC-1 10.* The next time you encounter a subject that requires N - 1 development, you could refer to your record and try developing the negative for 4 1/2 minutes instead. This should be closer to the correct time for your work. Eventually you will arrive at personal times that you can count on for good results.

If your shadow values are consistently too dark, and you are sure that your placements are correct, try using a slightly lower ASA the next time you photograph with that film. An empirical testing method like this one will make you very sensitive to any changes in your image quality. Many experienced photographers find that keeping a running record of their darkroom results is a very useful habit. This approach essentially amounts to doing a Zone System test every time you photograph. If done properly it is no less rigorous, and the results will be adapted to your personal working methods.

This method has two potential hazards that should be mentioned.

1. Any errors in your technique or problems with your equipment automatically become a part of the process. The specific nature of any mistakes or technical flaws will inevitably surface because your results will be inconsistent or illogical in particular ways. You will then have to carefully review your thinking and procedures and tune up your equipment until the problem is resolved. This is a healthy part of any learning process.
2. The visual evaluations you will be making as you go along will necessarily be very subjective. This process is very different from comparing your Zone III, for example, to a printed standard. If, on the other hand, you are consistently happy with the results you get, you will have accomplished a great deal.

Development time recommendations for a variety of films are available from a number of sources. Ilford publishes a list of development times for a long list of developers and films, that is available at many good camera stores. Kodak's data guide for black-and-white films also lists recommended Normal Development Times for Kodak products. Most film manufacturers also have toll-free numbers or web sites that offer free technical advice. (See Appendix M). Any good camera store can provide you with these numbers. *The Photo Lab Index* and Ansel Adam's *The Negative,* are

invaluable resources for information about developers and developing times. Charts of this kind provide useful starting points for determining your own specifications. You will most likely have to adjust your times as you go along.

ABOUT THE DEVELOPMENT TIME CHARTS

The development times provided below are the result of extensive tests done under carefully controlled conditions designed for accuracy and consistency and to avoid technical flaws such as reciprocity failure, lens flare, and so on.

> **Note**: For the technically minded, my test negatives were consistently printed at the minimum time that it took to render the film base plus fog density as maximum black on grade 2 paper. The negatives were hand-processed and printed with a diffusion enlarger and machine-print processes.

We began this process by asking a number of basic questions.

Q: Which are the most popular and widely used products?

A: As I mentioned above, if your favorite film or developer is not listed here, there should be something comparable that you can use to extrapolate your own time. Film speed is usually a reliable benchmark to use for comparison. If the film you want to try has an ASA close to one I recommend, use my time for that film as your starting point. Developers can generally be categorized by characteristics such as fine grain, high energy, and so on. See Appendix A.

Q: What is the highest film speed that renders a fully detailed Zone III and a Zone II that is black with texture?

A: Film manufacturers must necessarily use consistent and scientifically objective criteria for determining the ratings of their films. Photographers, on the other hand, need ASA ratings that they can count on to give them the amount of shadow detail they visualize when considering a given subject. This is a very subjective evaluation and will vary somewhat depending on the kind of work you do and other variables such as the paper grades you like, and so on.

The standard I have used for these tests is conservative and intended to give you as much exposure latitude as possible, the highest ASA, and good shadow detail in Zone III.

My goal is to produce negatives that would generally be easy to print on a normal grade of paper (grade 2). From this starting point you can begin developing your own personal standards.

You will notice that the effective speed of a given film varies depending on the developer used. Notice for example that Tri-X is rated as ASA 200 when developed in Kodak D-76, and ASA 400 when processed in Edwal FG-7 with a 9 percent solution of sodium sulfite. What this demonstrates is that different developers have very different effects or various films. See Appendix A for more information on this subject.

Q: What is the minimum development time that renders a fully textured Zone VII, and a Zone VIII that is white with some texture?

A: The Normal Development Times recommended by film and developer manufacturers are based on scientific standards such as "developed to a contrast index of 0.56." Anyone so inclined will discover that there are very rational reasons for doing it this way, but all that most photographers need to know is that a given development time will give them negatives with printable highlights.

It is always best to work with minimum times to avoid highlights that are blocked up. Higher than normal grades of papers can be used if more print contrast is needed. See Appendix C.

Standard developer temperatures and dilutions were used in the tests charted below unless the tests indicated that an alternative gave better results.

Agitation rate is another important variable that effects development time and film speed. My agitation procedure is outlined in Appendix A under "Processing Notes" and on page 172 of "A Primer on Basic Photography."

The following development times are suggested for diffusion-type enlargers. Reduce these times by approximately 15% if you print with a condenser enlarger or if you are processing your film in a Jobo processor. See Appendix F. The times are listed in minutes or fractions of minutes.

Notes: Development times that are shorter than 3 minutes in certain developers are listed as "N.R.", Not Recommended-because it is very difficult to avoid uneven development.

Practical experience (and Kodak data sheets, if you look closely) indicates that T-Max developer is not recommended for use with any sheet film. See the section on T-Max developer under "Developer Notes" in Appendix A.

DEVELOPMENT TIME CHARTS

EDWAL FG-7 WITH 9% SODIUM SULFITE DILUTED 1:15 AT 68 DEGREES. TANK DEVELOPMENT FOR SHEET OR ROLL FILM

FILM	ASA	NORMAL	N+1	N+2	N-1	N-2
T-Max P3200	2400	11	12	13.5	10	8.5
Tri-X	400	6.5	9	12.5	5	N.R.
T-Max 400	320	6.5	7	8	6	5
HP-5+	400	6.5	9	12.5	4.5	N.R.
Delta 400	400	6.5	7	8	6	5
Plus-X	125	4.5	5.5	7.5	N.R.	N.R.
FP-4+	125	6.5	9	12.5	5	N.R.
T-Max 100	80	6	6.5	7	5.5	N.R.
Delta 100	100	6.5	7	8	6	N.R
Pan-F+	50	4	5.5	8	N.R.	N.R.

KODAK D-76 DILUTED 1:1 AT 68 DEGREES TANK DEVELOPMENT FOR SHEET OR ROLL FILM

FILM	ASA	NORMAL	N+1	N+2	N-1	N-2
T-Max P3200*	1600	14.5	16	17.5	13	11.5
Tri-X	200	9	13	18.5	6.5	5
T-Max 400	200	10.5	11.5	13	9.5	N.R.
HP-5+	320	8.5	12	16.5	6	5
Delta 400	200	9	10	13	8	7
Plus-X	64	7	10	14	5	4
FP-4+	125	9	12.5	17.5	6.5	5.5
T-Max 100	80	11	12	13.5	10	9
Delta 100	80	10	11	12	9	8
Pan-F+	32	8.5	11.5	16	6	5

*These times are for Kodak D-76 stock solution.

KODAK XTOL DILUTED 1:1 AT 68 DEGREES
TANK DEVELOPMENT FOR SHEET OR ROLL FILM

FILM	ASA	NORMAL	N+1	N+2	N-1	N-2
T-Max P3200*	2400	16.5	18	20	15	13
Tri-X	320	9.5	13.5	18.5	6.5	5.5
T-Max 400	200	9	10	11	8	7
HP-5+	320	15	21	29	10.5	9
Delta 400	320	9.5	10.5	11.5	9	7.5
Plus-X	125	7.5	10.5	15	5.5	4.5
FP-4+	125	9	12.5	17.5	6.5	5.5
T-Max 100	50	9.25	10	11	8.25	7.5
Delta 100	100	10.5	11.5	12.5	9.5	8.5
Pan-F+	50	8	11.5	16	6	5

ILFORD ID-11 DILUTED 1:1 AT 68 DEGREES
TANK DEVELOPMENT FOR SHEET OR ROLL FILM

FILM	ASA	NORMAL	N+1	N+2	N-1	N-2
T-Max P3200*	1600	14.5	16	17.5	13	11.5
Tri-X	200	9	12.5	17.5	6.5	5.5
T-Max 400	200	9	10	11	8	7
HP-5+	320	9	12.5	17.5	6.5	5.5
Delta 400	320	8.5	9.5	10.5	7.5	6.5
Plus-X	125	6.5	9	12.5	4.5	4
FP-4+	80	8.5	12	17	6	5
T-Max 100	80	9	10	11	8	7
Delta 100	100	8	9	10	7	5.5
Pan-F+	50	8	11	15	5.5	4.5

*These terms are for ID-11 stock solution.

KODAK HC-110 DILUTION B (1:7 FROM STOCK) AT 68 DEGREES
TANK DEVELOPMENT FOR SHEET OR ROLL FILM

FILM	ASA	NORMAL	N+1	N+2	N-1	N-2
T-Max P3200	3200	12	13	14.5	11	9.5
Tri-X	400	6	8.5	12	4.5	N.R.
T-Max 400	200	6	6.5	7.5	5.5	N.R.
HP-5+	320	5.5	7.5	10.5	4	N.R.
Delta 400	200	6	6.5	7.5	5.5	N.R.
Plus-X	80	5	7	10	N.R.	N.R.
FP-4+	80	5.5	7.5	10.5	4	N.R.
T-Max 100	50	7	8	9	6.5	N.R.
Delta 100	80	4.5	5	5.5	4	N.R.
Pan-F+	32	3.5	5	7	N.R.	N.R.

ILFORD ILFOTEC HC 1:31 (FROM CONCENTRATE) AT 68 DEGREES
TANK DEVELOPMENT FOR SHEET OR ROLL FILM

FILM	ASA	NORMAL	N+1	N+2	N-1	N-2
T-Max P3200	2400	11.5	12.5	14	10.5	9.5
Tri-X	200	6	8.5	12	4.5	N.R.
T-Max 400	200	7	7.5	8.5	6.5	5.5
HP-5+	200	7.5	10.5	15	5.25	N.R.
Delta 400	200	7	7.5	8.5	6.5	5.5
Plus-X	80	6.5	9	12.5	5	N.R.
FP-4+	80	6.5	9	13	5	N.R.
T-Max 100	50	8.5	9.25	10	7.5	6.5
Delta 100	50	6	6.5	7.25	5.5	N.R.
Pan-F+	32	4	5.5	8	N.R.	N.R.

KODAK T-MAX DEVELOPER DILUTED 1:4 AT 68 DEGREES
TANK DEVELOPMENT FOR ROLL FILM ONLY*

FILM	ASA	NORMAL	N+1	N+2	N-1	N-2
Tri-X	400	5	6	7	N.R.	N.R.
HP-5+	400	6	7	8.5	N.R.	N.R.
Delta 400	400	6	7	8.5	N.R.	N.R.
Plus-X	125	4.5	5.5	6.5	N.R.	N.R.
FP-4+	125	5.5	6.5	8	N.R.	N.R.
Delta 100	100	6	7	8.5	5.5	5
Pan-F+	50	4	4.5	5	N.R.	N.R.

*T-Max developer is not recommended for use with sheet film.
See the Kodak T-Max section under "Developer Notes" in Appendix A.

KODAK T-MAX DEVELOPER DILUTED 1:4 AT 75 DEGREES
TANK DEVELOPMENT FOR ROLL FILM ONLY*

FILM	ASA	NORMAL	N+1	N+2	N-1	N-2
T-Max P3200	2400	10	12	13.5	9	7.5
T-Max 400	400	5.5	6	6.5	5	4.5
T-Max 100	100	6.5	7	8	6	5

*T-Max developer is not recommended for use with sheet film.
See the Kodak T-Max section under "Developer Notes" in Appendix A.

KODAK T-MAX RS DEVELOPER DILUTED 1:4 AT 68 DEGREES
TANK DEVELOPMENT FOR SHEET OR ROLL FILM

FILM	ASA	NORMAL	N+1	N+2	N-1	N-2
T-Max P3200	2400	10.5	12.5	15	10	N.R.
Tri-X	400	4	4.5	5.5	N.R.	N.R.
T-Max 400	200	4.5	5.5	6.5	N.R.	N.R.
HP-5+	320	4	4.5	5.5	N.R	N.R
Delta 400	320	4.5	5.5	6.5	N.R	N.R.
Plus-X	80	4	5	6	N.R.	N.R.
FP-4+	80	4	5	6	N.R.	N.R.
T-Max 100	100	7.5	9	11	6.5*	6*
Delta 100	100	5.5	6	6.5	5*	N.R.
Pan-F+	50	3	4	5.5	N.R.	N.R.

*To prevent the loss of shadow detail, place your Important Shadow reading on Zone IV instead of Zone III.

AGFA RODINAL DILUTED 1:25 AT 68 DEGREES
TANK DEVELOPMENT FOR SHEET OR ROLL FILM

FILM	ASA	NORMAL	N+1	N+2	N-1	N-2
T-Max P3200	3200	11	12	13.5	10	9
Tri-X	400	6	8.5	12	4	N.R.
T-Max 400	200	5	5.5	6	4.5	N.R.
HP-5+	320	14.5	20	28	10	8.5
Delta 400	320	6.5	7	8	6	5
Plus-X	80	4.5	6.5	9	N.R.	N.R.
FP-4+	125	11	15.5	22	8	6.5
T-Max 100	100	7	8	9	6.5	5.5
Delta 100	50	7.5	8.5	9.5	6.5	6
Pan-F+	50	4	5.5	7.5	N.R.	N.R.

ILFORD PERCEPTOL DILUTED 1:1 AT 68 DEGREES
TANK DEVELOPMENT FOR SHEET OR ROLL FILM

FILM	ASA	NORMAL	N+1	N+2	N-1	N-2
Tri-X	320	10	12	14	7	6
T-Max 400	320	14	17	N.R.	N.R.	N.R.
HP-5+	200	11.5	14	16	8	7
Delta 400	200	10	12	15	9	8
Plus-X	64	7	9.5	13	5	4
FP-4+	80	10	14	19.5	7	6
T-Max 100	80	14	15.5	17	12.5	N.R.
Delta 100	80	11.5	12.5	14	10	9
Pan-F+	50	12	16	22	8.5	7

Remember that the development times listed above are only starting points for determining your own standards. Refer to Appendix A, "Films, Developers, and Processing," for a comprehensive survey of the characteristics of the films and developers used in the above test.

Appendixes

APPENDIX A
FILMS, DEVELOPERS, AND PROCESSING

In spite of what advertising may suggest, no film or developer is ideal for every use. Developers and films all have very specific qualities that are best suited to particular applications. Your goal should be to define the kind of photography that you intend to do and decide on materials accordingly.

As you begin this process it is easy to feel that you may never learn enough about all of the various developers and films available and their effects. There is in fact a much more direct and practical way to approach this problem. What most photographers actually do is look at the work of a photographer they admire and use the film and developer that that photographer uses, at least as a starting point for their own work. This approach not only gives you a concrete model to follow, but you also can learn what the pitfalls and limitations of a particular film/developer combination are.

For this reason I have decided in this Appendix to give you as much practical information about what films and developers will do as I can. Of course, not every film and developer is included here, but the ones I have chosen cover most of the major products available in the United States and, more important, all of the major categories of films and developers that are made.

The first section, entitled "The Basics," describes these general categories and their uses. If you are already familiar with these basic concepts, skip this section and refer to "Developer Notes," "Film Notes," and "Processing Notes" for more detailed information. The section titled "Film and Developer Questions and Answers" summarizes my personal evaluations of how certain films and developers actually perform.

> **Note:** Given the scope of this book, only black and white materials and processes will be discussed.

118

Once you have chosen a given developer and film, stick with them until you are sure that you understand their advantages and disadvantages; only then should you begin experimenting with different variations. In the end you will find that the simpler your tools and methods, the easier it will be for you to accomplish your goals.

THE BASICS

Both films and developers fall into natural categories that make it easier to decide which combination is best for you.

Films

Films fall into three basic categories depending on the quality of the grain that appears when the negative is enlarged and the speed or sensitivity of the film to light. If you are not familiar with the relationship between ASA and image quality, refer to Appendix G and "A Primer on Basic Photography." See also below for a discussion of "Tabular Grain Films: T-Max and Delta."

Fine-Grain Films

If you are shooting well-lit landscapes, still lifes, or non-candid portraits with roll film, you will probably want to use a tripod and a relatively slow-speed, high-acutance, fine-grain film such as Kodak T-Max Delta 100 or Ilford Pan-F Plus. (Keep in mind that these recommendations are only guidelines for general use. The rule is, Anything that works in art is fair.) Slower films tend to have finer grain and more inherent contrast than films with higher ASA numbers. This is why, in situations where film speed is not a factor, most photographers try to use as slow a film as possible.

High-Speed Films

If you are shooting in low-light situations or taking pictures of moving subjects, you will need a faster film such as, Kodak Tri-X, Kodak T-Max 400, Ilford Delta 400, or Ilford HP-5 Plus. High-speed films have more grain and less inherent contrast than films with lower ASA numbers. Those shooting with view cameras should remember that fast films like Tri-X are only grainy when the negative is greatly enlarged. In extreme low-light level situations where maximum film speed is the priority films such as Kodak T-Max P3200 are ideal.

Medium-Speed Films

Medium-speed, semi-fine-grain films are designed for average situations where a high-speed or fine-grain film is not required. Kodak Plus-X and Ilford FP-4 Plus are good choices.

All of these films are excellent when handled properly.

Developers

The speed and grain characteristics of various films make choosing the right one fairly simple. Selecting the best developer is more complex for two basic reasons: There are dozens of good brands and different types of developers to choose from; and there is a general lack of objective information about what a particular developer will do. A good rule of thumb is: Find a photographer whose work you admire and use the developer that photographer uses.

Generally, developers fall into three basic categories: fine-grain, general purpose, and exotic.

Fine-Grain Developers

Fine-grain developers are ideal for negatives that need to be greatly enlarged. Unfortunately, these developers tend to produce negatives that appear less sharp. They also give you less film speed than standard developers. Some recommended fine-grain developers are Kodak D-23, Edwal FG-7 with a 9 percent solution of sodium sulfite, Ilford Microphen, and Acufine.

General-Purpose Developers

Standard developers are excellent for most films and ordinary lighting situations. The slightly increased grain that you get with these formulas is only a problem if you are making very large prints. Kodak's HC-110, Ilford's Ilfotec HC, T-Max developers and Edwal's FG-7 have the added advantage of being concentrated liquids. This eliminates having to dissolve powders in heated water before using them. Recommended standard developers: Kodak XTOL, Kodak HC-110, Kodak D-76, Edwal FG-7, Ilford ID-11, and Kodak T-Max and T-Max RS.

Exotic, Make-It-Yourself Formulas

Exotic developers are for adventuresome photographers looking for the ultimate developer for special purposes. The variety of different formulas available is staggering. For more information, consult *The Photo-Lab Index*, published by Morgan and Morgan; *The Negative,* by Ansel Adams; or *Photographic Materials and Processes*, published by Focal Press.

DEVELOPER NOTES

KODAK XTOL is a powder that comes in two-parts that can be mixed at room temperature. Designed as a general-purpose developer it gives very good film speed with good contrast and has the advantage of being self-replenishing. (See the note below.)

Note: All developers exhaust themselves as they are used due to the accumulation of residual by-products as you process film. Some are designed to be "one-shot" developers that you discard after using them once. Edwal FG-7 is an example. This guarantees that you are always using fresh developer, which is vital for consistent results, but this is clearly not the most economical or ecological darkroom practice. For this reason, many photographers and photo labs use developers that can be "replenished", which means that they can be brought back to full strength by adding a carefully measured amount of a special, concentrated batch of the same developer brand. "Self-replenishing" developers like Kodak's T-Max and XTOL have the advantage of allowing you to replenish them with a batch of developer mixed to the same dilution as your normal solution. You do this by simply bringing to volume of developer back to your normal amount, usually 1/2 or one full gallon.

KODAK D-76 is a general-purpose developer sold as a powder. It can be used either straight, as a stock solution (diluted from powder), or diluted one part stock to one part water. D-76 gives slightly finer grain and can be replenishable when used straight.

ILFORD ID-11 is very similar to D-76 but gives finer grain and is good for Expansion developments.

AGFA RODINAL is a concentrated liquid developer that produces grainy but extremely sharp negatives. Rodinal acts as a compensating developer when used in high dilutions.

EDWAL FG-7 is a fine-grain liquid developer that has a slight **compensating effect** (see Appendix E) when used at dilutions of 1:15 or greater. Adding sodium sulfite will reduce your development time and give you finer grain. To make a 9 percent solution of sodium sulfite, add 45 grams of sodium sulfite to 15 ounces of water. Add 1 ounce of FG-7 to make a 1:15 solution.

KODAK HC-110 is an excellent all-purpose developer that comes in liquid form, which makes it quick and easy to use. HC-110 produces negatives that are as fine-grained as those developed with Edwal FG-7 with sodium sulfite, but HC-110 provides greater contrast. HC-110 works well with Kodak T-Max P3200, giving good film speed and contrast. Kodak lists a number of dilution possibilities for HC-110 on the bottle. Dilution B is one part stock solution to seven parts water (1:31 from concentrate).

ILFORD ILFOTEC HC (High Concentrate) is a liquid developer similar to Kodak's HC-110 although my tests show that it gives slightly less film speed.

ILFORD PERCEPTOL is a softer-working, fine-grain developer that is useful for Contraction developments because of its relatively long Normal Development Times.

KODAK T-MAX is an excellent and versatile high-energy developer designed specifically for Kodak's T-Max films. T-Max gives good contrast and film speed with any film, but it is especially good with T-Max 100 and 400 when used at 75 degrees. T-Max developer comes in a liquid stock solution that is mixed 1:4 for a working solution.

> **Note:** Kodak T-Max developer is not recommended for use with any sheet film. Occasionally a dark, blotchy coating called **dichroic fog** will appear on the emulsion side of your film and can only be removed by vigorously washing the film by hand, which carries the risk of scratching the image. Because roll films don't use the same adhesive coatings as sheet film between the emulsion and the film base, dichroic fog is not a problem when T-Max developer is used with roll films.

KODAK T-MAX RS developer is very similar in quality to T-Max developer except that it produces negatives with slightly more contrast.

T-Max RS is formulated to be "self-replenishing." (See the note below Kodak XTOL developer.) Kodak recommends replenishing at a rate of 1 1/2 ounces per roll processed. This system is easy to use and has the advantage of making it impossible to overreplenish. When the second half gallon is used up, you can assume that the developer is exhausted and ready to be replaced.

Unlike T-Max developer, T-Max RS developer is recommended for sheet film because it is designed for use in machines and contains buffers that prevent the silver from replating on the surface.

FILM NOTES

Tabular Grain Films: T-Max and Delta

By applying Tabular Grain or T-Grain technology to black-and-white emulsions, Kodak and Ilford have produced films that have substantially less grain than standard emulsion films. *Tabular* refers to the much larger and flatter shape of the silver crystals in the emulsions of these films. The greater light absorption qualities of these flat crystals allows the manufacturer to produce a thinner emulsion that results in substantially finer grain.

Kodak's T-Grain films are T-Max P3200, T-Max 400, and T-Max 100. Ilford's T-Grain films are Delta 100 and Delta 400. The finer grain and excellent image quality of these films will no doubt make them very popular with serious photographers, but my test results indicate that T-Max and Delta have unusual characteristics that should be given special attention.

1. I found T-Max 400 and 100 and Delta 400 and 100 to be no faster than Tri-X or Plus-X respectively. The advantage of T-Grain films is that they have substantially finer grain. T-Max 100 has grain as fine as the old Kodak film Panatomic-X, but T-Max 100 is much faster.
 T-Grain films are also extremely unforgiving of underexposure. T-Max 400 and T-Max 100 look best when developed in T-Max or T-Max RS developer at 75 degrees, but be sure that you place your Important Shadow Area no lower than Zone III on the scale.
 Never use T-Max developer with sheet film. See the information on Kodak T-Max under "Developer Notes."
2. T-Grain films are extremely sensitive to changes in development time, temperature, dilution, and agitation rate. Inconsistencies in any of these variables will produce noticeable changes in the contrast of your negatives. For this reason, T-Max films are very useful for Expansion and Contraction developments. Make an effort to be as consistent as possible in your development procedures.
3. Because T-Grain films are unusually responsive to changes in development time, the normal Expansion and Contraction formulas do not apply to these films. See the section entitled "Expansion and Contraction Development Times" at the end of Chapter 8, "Zone System Testing: Method 1," for details.

4. Kodak indicates that T-Max films require less compensation for the reciprocity effect than do conventional films. Ordinarily when your indicated exposure is ten seconds, a fifty-second exposure is required, with a 20 percent reduction in your development time to avoid under-exposure and overdevelopment. With T-Max, Kodak recommends an exposure, of only fifteen seconds for a ten-second indicated exposure, with no reduction of your development time. (See Appendix H.) Standard reciprocity failure charts apply to Ilford's Delta films.

5. Longer fixing and washing times are required with T-Max films in order to clear special dyes added to the emulsion. These dyes will turn the fixer red and exhaust it faster than normal. Ilford's "Core-Shell Crystal Technology" allows Delta 400 and 100 to have the advantages of a T-Grain emulsion without the special dyes that cause T-Max films to stain the fixing bath.

Chromogenic Films

This class of films is based on color negative developing processes. These films have characteristics that are substantially different from normal black-and-white materials.Kodak's Professional T400 CN also has a T-Grain emulsion for finer grain and sharpness.

1. Because the image in a chromogenic negative is made up of densities of black-colored dye instead of particles of silver, they are less grainy.
2. Overexposure tends to reduce the appearance of grain because as the density of the negative increases, the microscopic spots of dye merge to form a continuous image. This allows you a great range of exposure latitude when working with these films; usually ASAs between 25 and 1600 can be used on the same roll with satisfactory results.
3. Because chromogenic films must be processed to C-41 color standards you cannot alter the development time to compensate for changes in subject contrast.

FILM AND DEVELOPER QUESTIONS AND ANSWERS

Students and friends inevitably ask a number of general questions regarding film and developer combinations. The following are my answers to these questions. Keep in mind that these are very subjective responses based upon years of testing and working with these products. Other photographers may have different preferences that are appropriate for their work.

The detailed explanations for these results can be found in this Appendix under "Developer Notes" and "Film Notes."

Q: What film/developer combination gives the finest grain with good shadow detail and the best overall contrast?
A: Kodak T-Max 100 in T-Max developer at 75 degrees.

Q: What film/developer combination gives the fastest speed with the least grain?
A: Kodak Tri-X in Edwal FG-7 with a 9 percent solution of sodium sulfite.

Q: Which developers give the finest grain with good shadow detail and the best overall contrast with the films you have tested?
A: See chart below.

FILM	RECOMMENDED DEVELOPER
Kodak P3200	Kodak HC-110 (B)
Kodak Tri-X	Edwal FG-7 with sodium sulfite
Kodak Plus-X	T-Max or Kodak HC-110 dilution B (roll film only; for sheet film use T-Max RS)
Kodak T-Max 400	Kodak T-Max at 75 degrees (roll film only; for sheet film use T-Max RS)
Kodak T-Max 100	Kodak T-Max at 75 degrees (roll film only; for sheet film use T-Max RS)
Ilford HP-5 +	Edwal FG-7 with sodium sulfite
Ilford FP-4+	Edwal FG-7 with sodium sulfite
Ilford Delta 400	Edwal FG-7 with sodium sulfite
Ilford Delta 100	Edwal FG-7 with sodium sulfite
Ilford Pan-F +	Edwal FG-7 with sodium sulfite

Q: Which developer gives the finest grain, the fastest film speed, and the best contrast with Kodak T-Max P3200?
A: Kodak HC-110 dilution B.

Q: Which developer/film combination gives the fastest speed and maximum grain for special purposes?
A: Kodak T-Max P3200 developed in Agfa Rodinal.

PROCESSING NOTES

There are a number of factors that will affect your development time. Please keep the following in mind.

AGITATION. The longer and more aggressively you agitate the film in the developer, the shorter your development time will be. Consistency is very important. My agitation plan for roll film is as follows:

> Constant agitation for the first thirty seconds
> Rest for thirty seconds
> Agitate for five seconds for every thirty seconds up to the
> total development time.

(See also page 172 in "A Primer on Basic Photography.")

Note: Jobo processors automate the agitation process by given the film constant agitation. For this reason your Normal Development times will be approximately 15% shorter when using these processors.

DILUTION OF THE DEVELOPER. It is extremely important that you accurately measure your chemistry every time you process your film. Changing the dilution has a dramatic effect on the contrast of your negatives. Very dilute developers reduce negative contrast. Higher concentrations increase contrast. (See Appendix D.)

TEMPERATURE. Once you establish a working temperature for your chemistry, make sure that you don't stray from this standard by more than one degree.

TANK VS. TRAY DEVELOPMENT. This applies to sheet film users only. With the **tray method**, the individual sheets of film are agitated continuously by hand in a tray of developer. Use a tray that is large enough to allow easy handling of the film. Trays with flat unchanneled bottoms are not recommended. This method uses less developer than the tank method, and because the agitation is constant, the processing times are shorter. Presoaking the film in a bath of 68 degree water will prevent the sheets from sticking together when you put them into the development bath. When the film is presoaked, thirty seconds should be added to the development time. Extreme care must be taken to avoid scratching the emulsion side of one piece of film with the corner of another. Also be careful not to touch a dry sheet of film with your wet fingers. The safest method for developing sheet film in a tray is as follows:

APPENDIXES wait

1. Fan the dry sheets so that they can be grasped individually.
2. Quickly immerse the film one shot at a time in the presoak bath *face up* to avoid trapping air bubbles against the emulsion.
3. When you move your film from the presoak bath to the developer, place each piece of film *face down* and keep the film from floating around.
4. To agitate, pull the bottom sheet out and move it to the top.
5. Keep repeating this process for the duration of the development time. Make sure that the sheets remain face down. This will protect the emulsion side of the film from being scratched.

With the **tank method**, the sheets are first put into individual metal hangers and then are developed together in an upright tank. To agitate sheet film in a tank, use the following method:

1. At the beginning of your development, slowly lower the hangers together into the development tank.
2. Tap them sharply against the top of the tank to dislodge any air bubbles that may be on the surface of the film.
3. Lift the hangers out of the developer together and tilt them to the side until the excess developer has run back into the tank.
4. Reimmerse the film and repeat step 3, tilting the hangers in the opposite direction.
5. Repeat steps 3 and 4 for the first fifteen seconds of every minute, following the agitation plan outlined above.

Proper sheet-film agitation requires careful planning and precision. Before you attempt either tray or tank development, I would suggest that you ask an experienced film processor to demonstrate how it is done.

Whichever method you use, always use fresh developer and develop the same amount of film in your tank or tray when possible. The more film you process in a given amount of developer, the faster the developer will be exhausted.

APPENDIX B
ALTERNATIVE METHODS FOR
EXTREME EXPANSION AND CONTRACTION
DEVELOPMENT

Expansion

With modern films and developers, Expansions beyond N + 2 are difficult to achieve without a serious loss of image quality owing to increased grain and fog. In general you should rely on higher than normal paper grades and/or negative intensification when extreme Expansion is required.

Intensification means processing the film through a special chemical bath with the intention of increasing the contrast of the negative after it has been developed and fixed. Ideally, intensification will add density to the highlight areas of the negative without greatly increasing grain. Kodak offers a prepared formula called Chromium Intensifier that requires you to bleach, intensify, and then redevelop your negative. This is effective, but a more simple method is to intensify the negative in a bath of selenium toner. To intensify negatives in selenium:

1. Presoak the negative in a bath of water for five to ten minutes.
2. Re-fix in a bath of hypo *without hardener* for five minutes.
3. Tone in a bath of Kodak Rapid Selenium Toner diluted 1:3 with hypo clearing agent for five minutes. Agitate continuously.
4. Clear in hypo clear and wash.

> **Note:** Selenium toner is highly toxic. This procedure should be done in a well-ventilated area. Read the instructions carefully.

Contraction

There are a number of techniques available when extreme Contraction is necessary to control the contrast of a very high contrast subject.

1. You may have to use a lower than normal paper grade.
2. If used properly a **compensating developer** will lower negative contrast while minimizing the loss of shadow detail.
3. The **Two-Bath** and **Water Bath** development techniques can sometimes be useful for extreme Contractions.

All of these processes are described in detail below.

It is important to remember that there will always be some loss of shadow detail when Contractions beyond N - 2 are necessary. This can be compensated for by placing your Important Shadow Area on Zone III 1/2 or Zone IV when you are planning an extreme Contraction.

APPENDIX C
CONTRAST CONTROL WITH PAPER GRADES

For technical reasons, paper grade 2, or variable contrast filter 2, is usually considered Normal for negatives with Normal contrast. For example, this is the grade of paper I used as the standard for my testing procedure (see Chapter 9, "Zone System Testing: Method 2"). This means that paper grade 2 would become the target of all of your Zone System negative contrast adjustments, and theoretically your negatives would print well on that grade.

On the other hand, it is possible to customize your Normal Development Time so that *any* grade of paper becomes Normal for you when you use a given film/developer combination. Experienced fine printers often do this because they have learned that a particular grade of paper best suits their aesthetic needs.

The general principles for adapting your Normal Development Time to fit a given grade of paper follow.

When compared to a standard Normal Development Time on grade 2, the *higher* the grade of paper you choose as your personal normal grade, the *shorter* your personal Normal Development Time will be with a given film/developer combination. This is because paper grades with *more* contrast (higher grade) require negatives with *less* contrast (a shorter Normal time).

Conversely, the *lower* the grade of paper you choose as your personal Normal grade, the *longer* your personal Normal Development Time will be for a given film/developer combination. This is because paper grades with *less* contrast (lower grade) require negatives with *more* contrast (longer Normal time).

Of course there are practical limits to how far you can take this process, and the only way to know precisely how much shorter or longer your time should be is to carefully do a test like the one outlined in Chapter 8 (page 85).

Note: The type of enlarger you use is also a factor in this process. The same negative will produce a print with approximately one grade more contrast when printed with a condenser enlarger than with a diffusion or cold-light enlarger. (See Appendix F.)

Once you have established your personal Normal grade of paper, and a corresponding personal Normal Development Time, it becomes possible to use paper grades that are higher or lower than this new Normal grade to achieve contrast control beyond the usual Expansion and Contraction methods described in this book: one grade *higher* than your Normal grade is roughly equivalent to the effect of N + 1; one grade *lower* than your Normal grade is roughly equivalent to the effect of N - 1.

My recommendations here are hedged because paper grade numbers are not strictly standardized among manufacturers. Printing the same negative on grade 3 of one brand of paper may give you the same contrast as grade 4 of another brand. This use of higher and lower paper grades can enhance the effect of Expansion and Contraction.

For example, if you are photographing a subject that you determine requires N + 3 development, which is beyond the range of normal Expansion techniques, you should give the negative N + 2 development and then print that negative on a grade of paper that is *one grade higher than your personal normal grade*. This will result in a print that is approximately equivalent to N+ 3.

Conversely, if you are photographing a subject that you determine requires N - 3 development, which is beyond the range of normal Contraction techniques, you should give the negative N - 2 development and then print that negative on a grade of paper that is *one grade lower than your personal Normal grade.* This will result in a print that is approximately equivalent to N - 3.

Careful testing is required to perfect this technique with your preferred materials. One reason that paper grade 2 or filter 2 is generally considered best for your Normal standard is that it is in the middle of the range of contrast choices available with most papers. Standardizing your negatives to grade 2 will give you the widest number of choices above and below that grade for creative contrast control.

APPENDIX D
DEVELOPER DILUTION

A number of film developers are specifically formulated to work well at a variety of dilutions. The following is a list of some popular developers and the dilutions at which they are commonly used:

Edwal FG-7	1:3 to 1:15
Agfa Rodinal	1:25 to 1:100
Kodak HC-110	1:3 to 1:30
Ilford Ilfotec HC	1:31 to 1:47
Kodak D-76	1:1 or undiluted

Recommended Normal Development Times and mixing instructions are provided with all these formulas.

Changing the dilution of a given developer has a dramatic effect on its characteristics and performance. As a general rule, developers that are more dilute produce negatives with softer tonal gradations and finer grain. Diluted developers are ideal for Contraction developments because of their relatively longer development times and because of the compensating effect (see Appendix E). In general, diluted developers cannot be reused, and you may notice some loss of effective film speed, causing you to use a lower ASA.

Negatives developed in more concentrated "high-energy" developers tend to have greater tonal separations and coarser grain. Concentrated developers are recommended for Expansions because their Normal Development Times are relatively short. These developers will generally allow you to use a higher ASA for a given film than developers that are less energetic.

Developers containing high concentrations of sodium sulfite (D-76, XTOL, Perceptol, ID-11, and Microdol-X) produce finer grain when used in their undiluted form. In high enough concentrations, sodium sulfite will act as a silver solvent and reduce graininess at the expense of image resolution.

APPENDIX E
COMPENSATING DEVELOPERS

These are very dilute, slow-working developers that take advantage of the fact that denser areas of the negative (the highlights) exhaust developer at a faster rate than thinner areas. This is because the highlight areas contain more exposed silver.

As the film develops, residual by-products (bromide ions) produced in the emulsion weaken the effect of the developer and slow the process. The function of agitation is to replace the weakened developer with fresh supplies. When the film is at rest between agitations in a compensating developer, the bromide ions build up at a much faster rate in the highlight densities of the emulsion than they do in the less dense shadow areas. This effect is exaggerated because a compensating developer is relatively dilute and therefore is less able to replace the exhausted developer saturated in the emulsion. This causes the highlights to increase in density at a much slower rate than the shadow areas. The shadows, in effect, are given a chance to increase in density, resulting in an overall decrease in contrast and better shadow detail.

Compensating Formulas

The following is a list of some popular compensating developers. See Appendix A for references to other developer formulas.

Kodak HC-110, diluted 1:30 from stock; average Normal Development Time: twenty-five minutes
Agfa Rodinal, diluted 1:100 from concentrate; average Normal Development Time: eighteen minutes
Edwal FG-7, diluted 1:15 (without sodium sulfite); average Normal Development Time: ten minutes

You should conduct your own tests with these developers to discover the correct times for your film.

Kodak D-23

If you are ambitious and have a decent scale for weighing chemistry, Kodak D-23 is a formula you can mix yourself. The ingredients are available from any chemical supply company or from Photographer's Formulary (see Appendix L). Follow the formula for D-23 carefully and mix the ingredients in the order given.

```
Water (125°F)...........................................................750  ml
Metol......................................................................7.5 g
Sodium sulfite.........................................................100  g
Water to make.........................................................1000 ml
```
The working temperature of D-23 is 68 degrees.

Two-Bath Compensating Formula

The Two-Bath method was made popular by Ansel Adams for extreme Contractions. It utilizes Kodak's D-23 formula listed above as part A, and the following formula as part B.

Two-Bath Formula: Part B
```
Water (125°F)..........................................................100 ml
Borax (granular).......................................................20 g
Water to make .........................................................1000 ml
```
The working temperature is 68 degrees.

The procedure for using this Two-Bath formula is as follows:

1. Agitate the film continuously for four minutes in part A (D- 23).
2. Move your film to part B and let it rest there, without agitation, for three minutes.

The result of the Two-Bath method should be contrast reduction equal to approximately N - 2. Two-Bath developer processes work because of the compensating effect described above. A classic variation of this procedure is the water bath development process.

Water Bath Development

This technique was designed to dramatically reduce negative contrast with a minimal loss of shadow detail. It works well when film emulsions are thick because it assumes that there will be enough developer saturated into the shadow areas of the emulsion to allow them to continue developing after the highlight areas have exhausted their developer.

In an effort to improve sharpness and reduce grain, film manufacturers have reduced the thickness of most modern emulsions to a point where water bath development no longer works as well. The only film with an emulsion thick enough for practical water bath development is Kodak Super XX Pan.

The basic technique for Water Bath Development is as follows:

1. Agitate your film in the developer bath continuously for thirty seconds.
2. Quickly transfer the film without draining it to a bath of water and let it sit without agitation for one minute.
3. Repeat these steps three times and then process, wash, and dry your film normally.

Any standard developer will work with this process.

APPENDIX F
CONDENSER AND DIFFUSION

ENLARGERS

The function of an enlarging light source is to provide enough light to cast the shadow of the negative onto the printing paper. Condenser and diffusion enlargers differ in terms of the quantity and the quality of the light they present to the negative.

The light from a **condenser enlarger** is usually provided by a tungsten bulb. The light from this bulb is focused on the negative through a series of large lenses called condensers. This focused light strikes the film in very straight, or collimated, rays.

The effect of a **diffusion enlarger** is much different. The light source is usually a fluorescent tube patterned into a grid. These tubes give off very little heat and thus are nicknamed cold lights. The light from this grid is diffused through a piece of translucent glass or plastic so that the light striking the negative is scattered as much as possible.

When light passes through a negative, it is scattered by the density of silver in the emulsion. The greater the density, the more the light is scattered. This is called the **Callier effect**. Collimated light from a condenser enlarger exaggerates this effect, giving the print more overall contrast and greater tonal separation. Because diffusion enlargers scatter the light more evenly across the surface of the emulsion, they render the true contrast of the negative more faithfully.

The advantages and disadvantages of condenser versus diffusion light sources can be summarized as follows:

CONDENSER ENLARGERS. The more a negative is enlarged, the more contrast is lost due to the scattering of light between the enlarging lens and the printing paper. Condenser enlargers compensate for this to a certain extent, which makes them very useful for printing small negatives, but there is a noticeable loss of tonal gradations, especially in the highlight areas of the print. Grain and dust are also more apparent with condenser enlargers. The extra contrast you can expect from condenser enlarging light sources means that your Normal Development Times will be shorter when compared to photographers printing with diffusion enlargers. It usually requires approximately 15% less development to compensate for this factor.

DIFFUSION ENLARGERS. As a rule, diffusion enlargers will require that you produce negatives with more contrast than if you were printing with a condenser enlarger. This means that your Normal Development Time is likely to be longer. They are also dimmer and thus require slightly longer printing times. On the other hand, diffusion light sources render much more subtle tonal gradations in the highlights and obscure dust and scratches. This makes them ideal for printing medium- or large-format negatives. Add 15% to your Normal Development Times if you switch from printing with a condenser enlarger.

APPENDIX G
ASA NUMBERS

Four interrelated numbering systems are commonly used to rate the speed of various films. This can be confusing if you do not understand how these numbers correlate with one another, but it is really very simple.

ASA numbers increase *geometrically* as the film speed increases. As the speed doubles, the ASA number also doubles. When compared to a film rated ASA 200, a film rated ASA 400 requires one-half the exposure (one f/stop less exposure) to produce a given density. Because of this logical relationship, and because ASA is still in common usage, I use ASA numbers as a reference for film speed throughout this book. ASA stands for the American Standards Association, now known as the American National Standards Institute.

DIN numbers are the European standard for film-speed rating. DIN numbers progress *logarithmically* As the film speed doubles, the DIN number increases by three.

ISO numbers combine ASA and DIN into one number. For example, Tri-X is rated ASA 400, DIN 27, and ISO 400/27.

EI stands for Exposure Index. These numbers are used in the same way as ASA numbers but indicate that the user determined the film speed through a testing procedure.

APPENDIX H
FILTER FACTORS, THE RECIPROCITY
EFFECT, AND BELLOWS EXTENSION FACTORS

All of these factors greatly affect your exposure.

Filter Factors

Colored filters are useful for increasing the contrast between objects that are different colors. A filter will transmit its own color and absorb its complementary color. Thus a red filter will lighten a red apple when used with black-and-white film and darken a blue sky. Filters can produce important effects, but it is necessary to remember that the filter is blocking some of the light that would otherwise be exposing the film. Unless you compensate for this lost light, the negative will be underexposed. Every filter is associated with a number called a **filter factor**. This number indicates how much exposure to add for each filter. For example, if the factor for a given filter is 2, the exposure must be increased by two times to get the proper exposure. Since each f/stop doubles the exposure as it opens up, a filter factor of 2 requires opening up one stop. A filter factor of 4 would require a two-stop adjustment. Because daylight has a bluish cast and tungsten light is reddish, the filter factors for daylight are slightly higher. (The one exception is a dark blue filter, #47, which has a higher tungsten filter factor number.) Filter factors are listed in the Kodak data guides for filters and black-and-white films.

The Reciprocity Effect

Ordinarily, f/stops and shutter speeds have an equal effect on exposure. Changing the f/stop from f/8 to f/11 is equivalent to changing the shutter speed from 1/60 to 1/125 of a second. In either case, the exposure is one stop less. This is because f/stops and shutter speeds are calibrated to be equivalent, or "reciprocal." Unfortunately, this is true only within a certain range of exposure times (camera shutter speeds). If your exposure is longer than 1/2 of a second or shorter than 1/1000 of a second, the reciprocity rule "fails."

For example, a negative exposed for 1/2 of a second at f/2.8 will give lower densities than one exposed for four seconds at f/8. The film will be underexposed even though according to your light meter, these two exposures should be the same. This is called "**reciprocity failure**". Assuming that you need to use f/8 for depth of field, the solution would be to use an exposure of f/8 at fifteen to twenty seconds. If this sounds imprecise, you will find that published reciprocity charts are very general. It is also necessary to compensate for the increase in contrast that results from such long exposures. Ten to thirty percent less development will be required for negatives that have been exposed for longer than 1/2 of a second.

Because of their unique grain structure, Kodak T-Max films require less compensation for the reciprocity effect than do conventional films. As stated above, with standard grain films, when your indicated exposure is ten seconds, a fifty-second exposure is required, with a 20 percent reduction in your development time to avoid underexposure and overdevelopment. With T-Max, Kodak recommends an exposure of only fifteen seconds for a ten-second indicated exposure with no reduction of your development time. Standard reciprocity failure charts apply to Ilford's Delta films.

For more information on the reciprocity effect, consult *The Photo-Lab Index*, *Kodak Professional Black and White Films* data book, or *Photographic Materials and Processes* published by Focal Press.

Bellows Extension Factors

To focus on an object very close to the lens, it is necessary to increase the distance between the lens and the film. This is important to know because if the film-lens distance becomes greater than the focal length of the lens, the f/stop numbers become inaccurate.

An interesting way to visualize why this happens is to imagine that you are inside a large camera that is being focused on an object approaching the lens. If the lens is set at f/11, as the lens gets farther away from the film, the size of aperture f/11 will appear to decrease. Eventually, f/11 will appear to be the size of f/22 from the film's point of view. The rule is: As the lens-to-film distance increases, the effect of a given f/stop will decrease. Unless you compensate for this, the negative will be underexposed when you use extension tubes on a 35mm camera or extend the bellows of a view camera beyond the focal length of the lens.

The bellows extension factor tells you how much exposure to add to get good results when doing close-up photography. There is a mathematical formula that can be used to compute this factor, but an easier way to figure it out is to use one of the many handy devices that have been developed especially for this purpose. Two examples are the Quick Stick, manufactured by Visual Departures in New York, and the Calumet Exposure Calculator.

APPENDIX I
A COMPENSATION METHOD FOR INACCURATE METERS

Light-meter accuracy and consistency are essential for good results. Many large camera stores and repair shops will run a simple "known light source" test on your meter for a small charge. If the test indicates that your meter is reading one-half to one stop under or over normal and cannot be adjusted for some reason, you can compensate for this by using an alternative ASA number. For example, if the meter is supposed to read f/5.6 at 1/125 set at ASA 400, but instead reads f/4 at 1/125, simply reset the ASA to 800. The meter will now register accurate exposures, and from now on ASA 800 will represent ASA 400 when that meter is used. To help you remember to double the ASA, tape a reminder to the outside of the meter.

This method will work if the meter is inaccurate by the same amount throughout the scale. If it is off by different amounts on the high and low ends of its range, leave it at the repair shop.

APPENDIX J
INSPECTION DEVELOPMENT

This classic technique allows you to examine the film for a few seconds while it is developing using a very dark green Kodak Safelight filter 3. The purpose is to give photographers an empirical method of determining when the negative's highlights are developed to the proper density. The film has to be at least two-thirds developed before you can safely turn on the light without danger of fogging the film. Read the directions that come with the filter very carefully.

Developing by inspection can be a useful technique to learn, but it takes a considerable amount of practice to master it. Modern films have thin emulsions and antihalation dyes in the backing, making it difficult to see more than dark shapes in the short time allowed.

APPENDIX K
EXPOSURE RECORD AND CHECKLIST
FOR ZONE SYSTEM TESTING
(See the following three pages)

Exposure Record

	SUBJECT	O	I	II	III	IV	V	VI	VII	VIII	IX	A S SPEED	B F STOP	C ASA	DEV
1															
2															
3															
4															
5															
6															
7															
8															
9															
10															
11															

FILM: ZONES A B C

CHECKLIST FOR ZONE SYSTEM TESTING

Instructions for sheet film are enclosed in boxes.
Check off each step as you proceed through the test.

MATERIALS

☐ Camera

☐ 4 rolls of film

☐ Developer

☐ Tripod

☐ Reflected-light meter

☐ Cable release

☐ Developer

☐ 24 sheets of film

☐ 12 film holders

☐ Large note pad

☐ Marker

☐ Paper (your normal grade and size)

☐ Neutral Gray Card

Load and label your film holders as illustrated in Figure 57.

☐ (Do you have four sets of three holders labeled A, B, C, and D?)

☐ **Step 1** Draw your test subject above the Exposure Record.

☐ **Step 2** Meter your Zone II, III, V, VII, and VIII areas and fill in these values on your sketch.

☐ **Step 3** Enter your readings on the Exposure Record. Place the Important Shadow Area on Zone III. Does the Zone VII reading fall on Zone VII?

☐ yes (go to next step)

☐ no (find another subject)

☐ **Step 4** Set up camera. Put a Neutral Gray Card in the image area. Does the Neutral Gray Card reading fall on Zone V?

☐ yes (go to next step)

☐ no (move the card)

☐ **Step 5** Calculate your exposures and fill in Exposure Record as illustrated in Figure 62.

☐ plan A (roll film)

☐ plan B (sheet film)

☐ **Step 6** Recheck your meter readings.
Have they changed?
☐ yes (go to step 2)
☐ no (go to next step)

Roll Film

☐ **Step 7** ☐ a. Expose one roll using the exposures noted on the Exposure Record.
☐ b. Recheck the meter readings and expose rolls 2, 3, and 4 using the same exposures.

Sheet Film

☐ **Step 7** ☐ a. Place the note pad in the image.
☐ b. In large letters, write 1A on the pad.
☐ c. Expose the #1 sheets of sets A, B, C, and D using the #1 exposure noted on the Exposure Record.
Did you change the **letter** for each exposure?
☐ yes (go to next step)
☐ d. Write 2A on the note pad.
☐ e. Expose the #2 sheets of sets A, B, C, and D using the #2 exposure noted on the Exposure Record.
Did you change the **letter** for each exposure?
☐ yes (go to next step)
☐ f. Repeat the above procedure for sheets 3, 4, and 5.

Consult Chapter 8, "Zone System Testing: Method 1," for instructions to complete steps 8-12.

APPENDIX L
SOURCES FOR ZONE SYSTEM-RELATED
PRODUCTS AND BOOKS

Zone VI Studios Inc. was founded by Fred Picker and is an excellent source of an amazing array of high-quality Zone System-related products. The company sells everything from self-sticking Zone Scales for light meters to cold-light heads for enlargers. For a catalog, write to Zone VI Studios Inc., 36 Chickering Drive, Brattleboro, VT 05301. Their fax number is (802) 257-5165.

Photographer's Formulary offers a wide range of hard-to-find photographic chemistry and prepared formulas in kit form with complete instructions. Contact Photographer's Formulary, P.O. Box 5105, Missoula, MT 59806, http://www.montana.com/formulary/index.html. (800) 922-5255, fax (406) 754-2896

Light Impressions Corporation is an excellent resource for photography texts and archival materials of all kinds. For a catalog, write to Light Impressions Corporation, 439 Monroe Ave., P.O. Box 940, Rochester, NY 14603.

Recommended Readings

General Photography Technique

The New Basic Photo Series
Ansel Adams
New York Graphic Society

An Ansel Adams Guide:
Basic Techniques of Photography
Books One and Two
John Schaefer
Little Brown

Basic Photography
M.J. Langford
Focal Press

Photography
Barbara London and John Upton
Amherst

Black & White Photography
Henry Horenstein
Little Brown

Developing
C.I. Jacobson and
R.E. Jacobson
Amphoto

APPENDIXES

Technical Books

Photographic Materials and Processes
Stroebel, Compton, Current, Zakia
Focal Press

*The Focal Encyclopedia
of Photography*
Richard Zakia & Leslie Stroebel
Focal Press

On the Zone System

The New Zone System Manual
White, Zakia, Lorenz
Morgan and Morgan

Beyond the Zone System
Phil Davis
Focal Press

*The Zone System for 35mm
Photographers
A Basic Guide to Exposure Control*
Carson Graves
Focal Press

The Zone System Craftbook
John Charles Woods
Brown and Benchmark

Digital Techniques

Essentials of Digital Photography
Akira Kasai and
Russell Sparkman
New Riders

*Making Digital Negatives
for Contact Printing*
Dan Burkholder
Bladed Iris Press

Creativity and Ideas

On Photography
Susan Sontag
Delta Books

Camera Lucida
Roland Barthes
Hill and Wang

Ways of Seeing
John Berger
BBC and Pelican Books

Light Readings
A.D. Coleman
Oxford University Press

On Being a Photographer
David Hurn and Bill Jay
LensWork Press

The Daybooks of Edward Weston
Edward Weston
Aperture

Looking at Photographs
John Szarkowski
Museum of Modern Art

Art & Fear
David Bayles & Ted Orland
Capra Press

APPENDIX M
A BRIEF DIRECTORY OF ON-LINE PHOTOGRAPHY-RELATED RESOURCES

The Internet has become a vast and prime source of free information about photography, and also a venue for the display of creative photo-related artwork. This Appendix makes no attempt to be a comprehensive listing of sites that are available. The following are some of my personal bookmarks that I have found useful or interesting. Also remember that the Internet is a volatile place so some of the sites listed may have moved or been discontinued by the time you are reading this.

> **Note:** On some browsers you will need to enter "http://" before the listed Internet addresses.

Technical Information

Alternative Photographic Processes
members.aol.com/sixbysixcm/CG.html

Darkroom On-Line
A wonderful resource for technical information.
www.darkroom-on-line.com/~lanoue/drlobby.htm

The Photographer's Formulary
www.montana.com/formulary/index.html

Zone System-Related Sites

The Zone System
www.cicada.com/pub/photo/zs/

The Zone System in Color Transparency Photography
idiom.com/~elight/earthlight/photo_tech_notes/color_zone_p1.html

Photography Company Homepages

Eastman Kodak
www.kodak.com/US/en/index.shtml

Focal Press
http://www.bh.com

Ilford Corp.
www.ilford.com/

General Photography Sites

Bengtha's Photo Page
http://www.algonet.se/~bengtha/photo/

Black and White World
Check out "The Photographer's Toolkit"
www.photogs.com/bwworld/

Digital Photography Resources
www.shortcourses.com/

Photo.Net
A site for general resources, essays and equipment.
photo.net/photo/

Photography Resources
http://www.photoresource.com/resource.html

Yahoo: Photography
The ultimate directory of on-line photography resources.
www.yahoo.com/Arts/Visual_Arts/Photography/

Some Virtual Galleries and Museums

After Image Gallery
One of the oldest fine art photo galleries in the country.
www.afterimagegallery.com/

The Ansel Adams Gallery
The web site of the famous gallery and bookstore in Yosemite Valley.
www.adamsgallery.com/

Aperture Gallery
www.aperture-photo.com/

California Museum of Photography
www.cmp.ucr.edu/default.html

Camera Obscura
Vintage and contemporary photography.
thor.he.net/~matheny/

Center for Creative Photography
A major museum and research center.
dizzy.library.arizona.edu/branches/ccp/ccphome.html

Center for Exploratory and Perceptual Art
CEPA.Buffnet.net/

Center for Photographic Art
On the site of one of the shrines of photography in Carmel, California.
www.photography.org/

The Center for Photography at Woodstock
A non-profit gallery and workshop organization for fine art photography.
www.cpw.org/

Dom Fotografie/House of Photography
Fine Eastern European photography.
www.student.kuleuven.ac.be/~m9624138/dfotky.htm

Equivalence: European Photography
equivalence.com/

Focus Gallery
A studio, gallery rental, photo lab services and a famous name.
www.sirius.com/~focusinc/

The George Eastman House
www.eastman.org/menu.html

Houston Center of Photography
www.mediaplace.com/hcp/

The Image Works
An important editorial and commercial stock agency.
www.theimageworks.com/welcome.htm

The International Center of Photography
A major center of documentary and fine art photography.
www.icp.org/

The International Photo Gallery Project
www.sentex.net/~mszane/ipgp/index.html

La Maison Europeenne de la Photographie
A center for European Photographic arts.
www.pictime.fr/mep/us/default.htm

Museum of Photographic Arts
One of the most creative photo-institutions in the world.
www.mopa.org/

The Photographer's Gallery
www.photonet.org.uk/

The Photographic Resource Center
www.bu.edu/prc/

Photographs Do Not Bend Gallery in Dallas
www.flash.net/~pdnb/

The PhotoZone Gallery
www.efn.org/~fotozone/

The Platinum Gallery
www.platinum-gallery.com/

Prague House of Photography
www.nearbycafe.com/php/php.html

The Southwest Museum of Photography At Daytona Beach Community College
www.dbcc.cc.fl.us/dbcc/smp/smphome.htm

Stock Solutions Gallery Site
www.tssphoto.com/foto_week.html

Third Eye Photography Collection
www.photocollect.com/

Time Life Photo Sight
The best of the Time Life archives.
www.pathfinder.com/@@bKrGnAcAvg3ft*mI/photo/index.html

Zone I Gallery
A showcase for African-American photography.
www.gate.net/~eak3/

Zone Zero Gallery
A very sophisticated site featuring a gallery, bookstore and a forum.
www.zonezero.com/

Some Other Art-Related Photography Sites

Artlinks
A great resource site maintained by the Society of Photographic Educators.
www.spenational.org/artlinks.html

Arts Wire
On-line communications for the arts.
www.artswire.org/

LensWork Quarterly
Features a gallery, essays and interviews.
www.teleport.com/~lenswork/lwg.htm

The Light Factory
A site for innovative creative projects.
www.lightfactory.org/

The Manchester Craftsmen's Guild
William E. Strickland's center of art and community service.
artsnet.heinz.cmu.edu/mcg/

The Mother Jones International Fund for Documentary Photography
The internet exhibition and information site for an organization providing grants to social-documentary photographers from all parts of the world.
www.motherjones.com/photofund/

The Nearby Cafe
A gathering place for artists, creative projects, organizations and other cyber-cultural activities. Check out their "Hot Links" page.
www.nearbycafe.com/

The Society for Photographic Education
www.spenational.org/

Urban Desires
A very sophisticated site of on-line cultural material.
www.desires.com/features/footprint/

The Visual Studies Workshop
www.isc.rit.edu/~vswwww/

Photo-Artist Sites

Darryl Baird
www.why.net/users/rosebud/

Chris Johnson
www.chris-iris.com

Mary Ellen Mark
www.maryellenmark.com/home/index.html

Jim Marshall Photography
Personal site of the legendary photographer of early rock music.
Www.marshallphoto.com/

Sebastiao Salgado
One of the world's great documentary photographers.
www.shama.com/sebastiaosalgado.html

Joseph Squire
A beautiful and complex art piece called "The Place."
www.art.uiuc.edu/ludgate/

To Save a Life, Stories of Jewish Rescue
Ellen Landweber's labor of love.
www.humboldt.edu/~rescuers/

Virtual Bookstores/Magazines and Journals

The Critical Eye
A magazine of contemporary images, ideas and issues.
www.thecriticaleye.com/

Double Take
Photography and words by Alex Harris and Robert Coles at
Duke University's Center for Documentary Studies.
www.duke.edu/doubletake/

Photo-Eye Books & Prints
The world's largest on-line photography bookstore.
www.photoeye.com/

Photography in New York
A bi-monthly guide to local, national and international exhibitions.
www.photography-guide.com/

Photo Metro
A periodical of photography and current issues.
photometro.com/content.html

The Photo Review
A journal, gallery and photography-related newsletter.
www.libertynet.org/photorev/

Sight Photography
On-line magazine of fine photography.
Sightphoto.com/photo.html

APPENDIX N
EXAMPLES: ZONE SYSTEM APPLICATIONS

The idea for this Appendix was inspired by my favorite of Ansel Adams' books: *Examples: The Making of 40 Photographs*. In this classic, Ansel describes in great detail, and with thoughtful autobiographical comments, how he created many of his greatest images. His book allows one to begin to understand the complexities of his creative process and the role the Zone System played in making his photography masterful.

Contrary to some misconceptions, the Zone System is an extremely versatile tool with applications in many areas of photographic practice. This section demonstrates how you can apply the Zone System to color, architectural, digital, fashion, figurative and documentary photography.

The five participating photographers were asked to describe in their own words how the Zone System contributed to the creation of their images. These statements represent very personal approaches and illustrate how, with experience, the Zone System can be adapted to a wide range of photographic problems.

The common denominator in all these examples is *previsualization.* The ability to use the Zone Scale to form a mental image of your final print before taking the picture is a powerful creative advantage. Once the image is previsualized, the problem of how to achieve the desired result depends on the nature of the shooting circumstances and your materials.

My example of photographing with an automatic camera using color film is intentionally very far from the conventional approach but it demonstrates the Zone System's flexibility.

I would like to thank Robert Bruce Langham III, Dan Burkholder, Anne Nadler, Judy Dater, David Bayles and Julio Mitchel for their cooperation in preparing these examples.

Chris Johnson

June in Sèvres was taken in a small town outside of Paris with an Olympus XA 35mm camera using Kodacolor II film normally rated at ASA 100. I previsualized this as a rich, somber image with saturated color and June's back as a bright, pure form against the dark grass.

The XA is an aperture-preferred automatic camera, and its recommended exposure would have shown detail throughout the image. To bracket exposures with automatic cameras, it is necessary to bypass the meter's preference by changing the ASA setting according to the following rule: **Using a higher than normal ASA rating will decrease the exposure, while using a lower setting will increase it.**

In taking this picture, I first exposed one frame using the normal ASA and another at ASA 150. This in effect fooled the camera's built-in meter into placing its readings one-half zone lower than normal, resulting in the image shown.

June in Sèvres, 1983 (original in color)

Robert Bruce Langham III

I was exploring an old building not intending to photograph, when I found the attic three floors up. The space was tight. The light was harsh to non-existent. Illumination came from an overhead trap door. Wasps and spiders lurked in every shadow. I returned three times over the course of a month, bringing magnolia and yucca blooms from the overgrown lot below and finally Tri-X 5 x 7 pre-exposed to Zone II. The development times shrank to the minimum dared. Minus three. I boosted the shadows with reflectors.

The negative looked odd on the light table because of the pre-fog but prints on grade two with some dodging and burning, not much, and all in obvious places. On palladium paper from the Palladio Company in Cambridge it contacts directly.

This image was the end, though I didn't know it, of a ten year period of photographic wandering. I was at the edge of getting untangled. It is part of a small but popular portfolio of architectural work not much shown. I feel like I came out of the dark, up the ladders, and climbed into the light.

ROBERT BRUCE LANGHAM III is a photographer and writer who lives and works very well, right where he was born in Tyler, East Texas.

CAMERA:	Deardorff 5 x 7, 90mm lens
FILM:	Kodak Tri-X sheet film, rated at 160
EXPOSURE:	F/32 (or so) at several seconds
DEVELOPER:	Kodak HC-110 (B)
DEVELOPMENT:	Normal Minus 3
PRINT:	Contacted on palladium paper from the Palladio Co. Editions of 40

The Attic, Lewis Hotel, 1980

Dan Burkholder

Digital Zone System?

Looking over the way different people use the Zone System, I'm reminded of the fable of the blind men examining the elephant: the man feeling the elephant's leg says, "an elephant is like a tree," the one feeling the ear says, "an elephant is like a leaf". . . and on it goes. The range of Zone System interpretations really isn't very different!

There was a time in my own image making when I used the Zone System more traditionally. That was way back when I used a view camera and spot meter to place my shadows and measure highlights to determine times for film development. Times have changed for me and the way I make photographs. For nearly seven years I've been shooting nothing but 35mm and then scanning the negatives to work them over in Photoshop. I then generate an enlarged digital negative that I contact print on hand-coated platinum/palladium. What hasn't changed is the need to make tonal decisions!

Part of the learning curve problem with Photoshop is the new language it introduces to photographers. Instead of thinking Zone IV for dark gray with lots of detail and Zone VII for highlights on wet bricks, I've had to recalibrate my eye (and brain, a much more difficult task!) to look for 80% dot for the dark gray and 12% dot for the wet bricks. The thinking is the same; just the vocabulary has changed. The important thing is that it was my traditional grooming within the Zone System that bred a discipline for tonal examination and good image decision making! And (both sadly and reassuringly) when the final print doesn't turn out like I'd hoped, it's usually because of bad judgment calls on my part, not because I need a better meter, a more sensitive densitometer . . . or faster computer!

Now let's see (says Dan, closing his eyes and feeling his computer monitor) . . . this digital imaging stuff is just like an expensive television that crashes!

DAN BURKHOLDER'S platinum prints have been exhibited and published internationally. The second edition of his award-winning book *Making Digital Negatives for Contact Printing* will be out in the late summer of 1998.

Rodential Resurrection, 1998

Anne Nadler

I previsualized *Lagrima de la Luna Zegarra and Barbie* as the combination of two different lighting patterns. I wanted the background to be Zone V with stripes of Zone VII and the model's skin Zones IV and VI, with her hair and legs in shadow as Zone II.

To get this effect, I first bounced a tungsten light off a taped mirror and took an incident reading of the background with my Minolta flash meter set to the "ambient" mode. The reading was f/16 at 1/8 of a second. The background highlights were one to two stops brighter than this reading.

After positioning the model on a pedestal ten to twelve feet in front of the background, I used the modeling light on one head of my Balcar 1,200-watt second strobe to determine the position of the key light, then added fill with white foamcore panels around the model. I needed a large opaque panel to keep the strobe from overexposing the background.

My exposure of f/16 at 1/8 of a second placed the background on Zone V. Using Polaroid test shots with my Hasselblad camera, I determined that setting the strobe to one-quarter power would balance the model against the background according to my previsualization.

ANNE NADLER is a fashion photographer and stylist living and working in the San Francisco Bay area.

FILM:	Kodak Plus-X
ASA:	80
DEVELOPER:	Edwal FG-7 with 9 percent sodium sulfite
DEVELOPMENT:	Normal

Lagrima de la Luna Zegarra and Barbie, 1984

Judy Dater

This untitled photograph was taken very late in the afternoon after the sun had set. I was attracted to the strange and inexplicable white boulder sitting on the dark red-brown earth. I wanted to heighten the contrast of the white rock, rope, and figure against the dark ground. I metered the earth and placed it on Zone III. Then I metered the rock and found that I would have to develop the film at N + 2 to bring it up to Zone VII. This produced the desired effect.

JUDY DATER is one of the best-known fine-arts photographers in the world. Her work has appeared in major museum exhibitions and photography publications, and she has been awarded the Dorothea Lange Award of the Oakland Museum and the Guggenheim Award for her outstanding contributions to photography. She is the author of *Women and Other Visions* with Jack Welpott and *Imogen Cunningham: A Portrait* and *Cycles* published in 1994.

FILM: Kodak Tri-X, 4 x 5
ASA: 200
DEVELOPER: Kodak HC-110, Dilution B
DEVELOPMENT TIME: 10 minutes

Untitled, 1983

David Bayles

This photograph was made with a view camera in the early 1970s, under the influence of reading John Cage and of wondering about randomness. I deliberately sought randomly organized objects as subjects - among them scatterings of driftwood imbedded in wind-smoothed sand (see Figure 14, page 22) and jumbles of fallen flowers and leaves.

But by November, fallen leaves are drab. The negative was developed about N+2; even so, there was a need for considerable burning of the darker values and some holding back of the lighter ones, all on fairly contrasty paper.

There is a kind of picture that glows even though the range of tones is quite compact, deep, and relatively soft. While such pictures may be hard to print, the tonalities are not really hard to previsualize. The harder part is the anticipation of what - if anything — is the real content.

DAVID BAYLES studied photography with Ansel Adams and, together-with Ted Orland, is the author of *Art and Fear: Observations On the Perils (and Rewards) of Artmaking.* David's work has been widely exhibited. He lives and works in Eugene, Oregon.

Untitled, 1970's

Julio Mitchel

I begin by setting my meter to an ASA that gives me one stop more exposure than the manufacturer's indicated speed, (they usually exaggerate). Then I take a reflected reading as close as possible without disturbing the subject in the area of the darkest tone where I want the minimum amount of detail. Back in the darkroom I develop for the highlights. Generally this means 20% less development under normal contrast lighting conditions. If the lighting is completely flat I then leave my reading at the manufacturer's given ASA and then I develop at the "normal" processing time. My photograph of jazz trumpeter Jimmy Robinson was made this way.

Given the fact that in the real world, life is not perfect,considering the subject matter that I deal with, and, not having the luxury of landscape or studio photographers, I sometimes have to tailor my technique. In situations where the contrast is extreme, I wait for the most important part of my subject to face the highlights and I expose for that, letting the shadows go black. That's how the image of the musicians and children in Ecuador was done. All of this assumes that I intend to print with a coldlight enlarger.

JULIO MITCHEL is one of the world's great documentary photographers. He has produced major bodies of work (most of these unpublished) on such diverse subjects as the exploitation of juvenile boxers, the troubles in Northern Ireland, the influences of military and political power on the peoples of Latin America, the dynamics of love, the creative lives of jazz musicians and the Statue of Liberty as a metaphor for the ironies of freedom in America.

The two books on his work are *Triptych,* 1990 and *Do You Love Me,* 1991. He is the recipient of numerous grants and awards and his work has been exhibited throughout the world.

Jimmy Robinson at Home

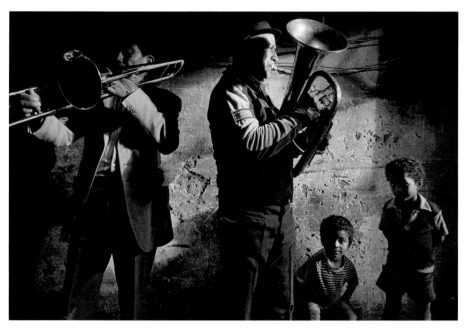

Ecuador, from "South of the Border"

A Primer on Basic Photography

This section is designed for students who need a brief review of basic photography to understand better some of the terms and concepts used throughout this book. In general, this chapter is a summary of those principles and techniques that relate to film exposure and development. Because the primer is intended to serve only as an aid to learning the Zone System, many important subjects are not covered in detail. For a more comprehensive text on basic photography, I recommend the following books:

1. _Photography_, London and Upton, Amherst
2. _Basic Photography_, M. J. Langford, Focal Press
3. _The New Basic Photo Series_, Ansel Adams New York Graphic Society
4. _Photography: Art and Technique_, A. A. Blaker, Focal Press

Unfortunately, photography is notorious for being complicated and difficult to learn. In the beginning, it is easy to get lost in the maze of photography's many inverse relationships. At every step it seems as if something light is turning something dark, which in turn causes something else to become light again. Confusion is understandable, but photographic processes are easier to comprehend if you keep in mind that you will have to deal with a limited number of very simple materials that consistently perform very simple functions.

PHOTOGRAPHIC EMULSIONS

The essential component of photography is a light-sensitive coating called an **emulsion**. When this emulsion is spread on one side of a piece of transparent material, we call it **film**. When an emulsion is applied to a piece of paper, it is used to make **photographic prints**. Film and prints may appear to be very different, but their emulsions are essentially the same.

167

Photographic Emulsions

Film Printing Paper

Figure 1: *Film and paper emulsions.*

All photographic emulsions respond to light in a simple way: Wherever the emulsion is exposed to light, a fine layer of metallic silver will be formed after development. The greater the amount of exposure, the more dense the deposit of silver will be.

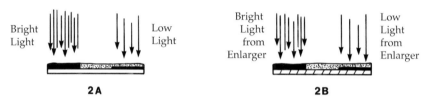

Figure 2: *Film and paper densities.*

THE NEGATIVE

On the film, these densities of silver are seen as the shadow-like reversed images we call the **negative**. The negative image is tonally reversed because any area of the scene that is bright will produce a dark layer of silver on the film. Conversely, a darker area of the scene will result in a relatively thin or transparent area on the film. See Figure 2A.

THE PRINT

The photographic printing process reverses the light-to-dark effect of the negative. The enlarger projects the shadow of the negative onto the emulsion of the paper. Once again, the light that passes through the transparent parts of the negative (corresponding to the darker parts of the subject) produce dark layers of silver on the white paper after development. The more transparent a given area of the negative is, the more light it will transmit to expose the paper and the darker that area of the print will become. The areas of the negative that are more dense (corresponding to the lighter areas of the scene) block more light. As a result, those areas of the print remain light. In this way, the lifelike image of the print will be produced.

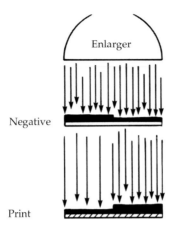

Figure 3: Enlarger, negative, and print.

The overall tonality of a print can be made lighter or darker by increasing or decreasing the amount of light that exposes the paper. Selected areas of the print can be darkened by adding more light to those areas. This is called **burning in**. If you want to make a certain part of the print lighter, all you have to do is hold back the light in that area with your hand or a tool. This is called **dodging**.

To distinguish between the light and dark areas of the subject and the light and dark areas of the print, subject brightnesses are called **subject values**. The gray, black, and white areas of the print are called **print values**, or **tones**.

Let's summarize what we have learned about emulsions, negatives, and prints:

1. The photographic emulsions of the films and prints are essentially the same. When an emulsion is exposed to light, it produces a density of silver after being developed. The greater the exposure, the greater the density.
2. A light value in the subject produces a high density in the negative, which results in a light tone in the print.
3. A dark value in the subject produces a low density in the negative, which results in a dark tone in the print.

Memorize these three principles before you go on.

PROCESSING

After a photographic emulsion has been exposed, it must be processed for the image to appear and remain stable. Processing means putting the emulsion through a series of chemical baths called developer, stop bath, and fixer. The chemistry and procedures are essentially the same for processing film and paper. The main difference is that film processing must be done in complete darkness to prevent the film from becoming fogged. Print processing can be done under a red-filtered light called a safelight. You should read the instructions supplied with all chemicals before using them.

Step 1: Developer

Before an exposed emulsion has been processed, there is no noticeable change in its appearance. At this point, the negative is said to contain a "latent image." The developer chemically converts this latent image to the visible silver image that makes up the negative and print. Remember that **the longer the emulsion is left in the developer, the more dense these deposits of silver will be**. If film is left in the developer for too long, these deposits of silver will become so dense that they will block too much of the light from the enlarger, and the print will be too white and contrasty. This effect is called overdevelopment. If a negative is underdeveloped, areas of the print that should be white will instead be gray, and the print will be dark and muddy. Prints that are under- or overdeveloped will either be too light or too dark, respectively. For this reason, the development stage of the process must be timed carefully. As you will learn from this book, the correct development time for film depends on the contrast of the subject. The standard development time for most photographic paper is from two to four minutes. For more information on developers, refer to Appendixes A, D, and E.

Step 2: Stop Bath

Because the timing of the development stage of the process is so critical, it is important that the emulsion stop developing as soon as the proper density has been reached. Developers must be alkaline to work. Because stop baths are acidic, immersing films or papers in a stop-bath solution will stop the developing process immediately. A fifteen- to thirty-second rinse in fresh stop bath is sufficient.

Step 3: Fixer (Hypo)

The fixing bath dissolves the remaining unexposed silver in the emulsion and allows it to be washed away. It is important that the fixing stage of the process be complete because any residues of unexposed silver will eventually stain the film or print and ruin the image. If your fixer is fresh and properly diluted, the minimum time that you should fix your negatives and prints before turning on the white light is two minutes for negatives and one minute for prints. Certain rapid fixers reduce the time required for complete fixing. Be sure that you read the manufacturer's instructions very carefully for proper dilutions and times.

Step 4: Washing

After your negatives or prints have been processed, they must be thoroughly washed in clean water to remove any traces of fixer from the emulsion. The use of a hypo clearing agent will greatly reduce the amount of washing time that is necessary to do a good job. Once again, carefully follow the manufacturer's instructions. Improperly washed negatives and prints will become stained.

Step 5: Drying

Many photographers take drying for granted, but it is easy to ruin a good negative or print at this point. A wet emulsion is very soft and can be scratched or attract dust if you are not careful.

Even more serious are the uneven densities that can form in negatives because of drops of water drying on the surface of your film. To avoid this you should always use a wetting agent in your final rinse to prevent spotting. This is not necessary when drying prints. Be sure to dry your negatives and prints in a clean, dust-free area.

Efficient processing is essential for getting good results in your photography. There is nothing more frustrating than spoiling a good negative by being sloppy or careless. Particular attention should be paid to the following points:

1. **Cleanliness.** Many unnecessary negative and print defects are caused by not washing your hands, tanks, trays, and reels carefully. Traces of fixer or developer on your fingers can easily leave stains on your prints that cannot be removed. Keep in mind that even a soiled towel or a contaminated light switch can transfer chemicals to your hands if you are not careful. The first time you discover a thumbprint etched into your favorite negative, you will appreciate the importance of being careful and clean.

2. **Agitation.** Agitation means causing your photo-chemistry to circulate and flow around the film or paper by keeping the development tank or printing tray in motion for a given amount of time during each stage of the process. This is necessary for the development and fixing of the emulsion to be even and complete. Film agitation is usually done by inverting and rotating the tank in a continuous and rhythmic twisting motion. The proper film agitation motion is infinitely easier to demonstrate than describe. One manual recommends that you use a "quasi-spiral torus motion." I would suggest that you find a friendly camera salesperson or photographer and ask him or her to show you how it is done. You might want to check his or her negatives and prints to see whether he or she has trouble with development streaks or air bubbles.

Correct agitation is especially important during the development stage of the process. If the motion you use fails to circulate the developer evenly around your film, your negative will have areas of uneven density that will show in your prints. Jerky or consistently violent agitation movements can create bubbles in the developer that can stick to your film and cause spots. To dislodge any of these bubbles, you should rap your tank against a hard surface after each agitation. Perhaps the most important thing to remember about agitation is that **the longer and more aggressively you agitate, the faster your film will develop**. For this reason, it is important that you establish a definite plan for your agitation and follow it religiously. This is especially important during the development and fixing stages of the process. A typical agitation plan would be:

For developments from 3 to 4 minutes - Agitate continuously.
For developments from 4 to 15 minutes-Agitate for 30 seconds, rest for 30seconds, then agitate for 5 seconds of every 30 seconds thereafter.
For developments longer than 15 minutes-Agitate continuously for one minute, rest for the next minute, then agitate for 30 seconds of every two minutes thereafter.

3. **Temperature.** It is very important that you adjust the temperature of the processing solutions before you begin using them. The cooler photo-chemicals become, the less efficient they are. Conversely, the warmer your chemicals are, the faster they will work. Most photo-chemicals are formulated to work at 68 degrees. If for some reason you have to use your chemistry at a higher or lower temperature, consult a time and temperature conversion chart for the correct development time at a given temperature. These are usually provided with your developer.

It is also very important that the temperature of all your chemicals is the same. This includes the water you use to wash your negatives and prints. A more than 1- or 2-degree variation in the temperature of your chemicals can seriously damage the quality of your negatives.

4. **Dilution.** Carefully follow the manufacturer's mixing instructions for all your photo-chemistry. Inconsistent dilution of your chemistry will make it impossible for you to control or standardize your processing results. Developer or fixing solutions that are either too dilute or too concentrated will drastically affect the amount of time it takes to produce the best results. The rule is: **The more concentrated the developer and fixer, the faster they will work.** Of course, the reverse is also true. The more dilute the photo-chemistry, the longer your processing time will be. For more information about dilutions, refer to Appendix D.

As you can see, agitation, temperature, and dilution are processing variables that must be carefully controlled to give your photographic work the consistency you need. When you become more experienced, you will discover that there are advantages to modifying all these controls, but in the initial stages, it is a good idea to consider development time the only variable that you can reliably control.

Film Processing

Step 1: Development	3 to 30 minutes
Step 2: Stop bath	30 seconds
Step 3: Fixer	5 minutes (check instructions)
Step 4: Rinse	2 minutes
Step 5: Hypo clear	3 minutes
Step 6: Final wash	15 minutes
Step 7: Wetting agent	1 minute
Step 8: Dry	

> **Note:** The exact development times for film will vary greatly according to a number of factors, including the film you are using, the developer and dilution, and most important, the contrast of the scene being photographed. This subject is covered thoroughly in Chapter 6 of this book.

Print Processing

Step 1: Development	2 to 4 minutes
Step 2: Stop bath	30 seconds
Step 3: Fixer	5 minutes
Step 4: Wash	2 minutes
Step 5: Hypo clear	2 minutes
Step 6: Final wash	1 hour (archival)
Step 7: Dry	

ASA

By altering the size and composition of the silver grains in the emulsion, films can be made more or less sensitive to light. The more sensitive an emulsion is, the less light it takes to produce a given density. Very sensitive films are said to be faster than films that are less sensitive because they allow you to use a faster shutter speed in a given lighting situation. Films of various speeds are assigned numbers by the American Standards Association. These are called ASA numbers. The important thing to remember about ASA numbers is that **the higher the film's ASA number, the faster the film.** Thus a film rated ASA 400 is more sensitive to light than a film rated ASA 125. Faster films tend to be more grainy than slower films, but they are an advantage when you are shooting in low-light situations.

You will learn much more about ASA and its effect on exposure and development in the main body of this book, but the essential concept is as simple as that. See Appendix G.

PAPER GRADES

Photographic printing papers are available in a wide variety of textures, thicknesses, and tonalities. **Resin-coated (RC)** papers require much less washing and dry more quickly than **fiber-based papers**. Fiber-based papers are generally preferred for exhibition-quality printing because they are more archival. There are a number of excellent, exhibition-quality papers currently on the market. These include Ilford Galerie, Ilford Multi-grade Fiberbase, and Kodak Elite, which has an extra-thick paper base. Brilliant is an extremely fine paper available by mail from Zone VI Studios (see Appendix L). Single-weight papers are less expensive but are more vulnerable to creasing than double-weight papers. "Warm-tone" papers print with a brownish or sepia tone, while normal or "cold-tone" papers are more neutral. To become familiar with the variety of papers available, compare the paper sample books displayed at many photo supply stores.

One fundamental characteristic of a photographic paper is its **contrast.** Figures 4A and 4B illustrate the difference in contrast between two papers of different "grades" used to print the same negative.

Figure 4A: Paper grade 2. *Figure 4B:* Paper grade 4.

Figure 4A is "softer" or "flatter" than 4B and has more gradual transitions from one tonal value to another. Figure 4B has greater separation between print tones that are relatively close in value. This is especially visible in the background and in the child's face. **Tonal range** and **tonal separation** are two ways of defining the contrast of a photographic print. While the tonal range of different prints may be the same, meaning that the blacks are just as black and the whites as white, higher-contrast papers separate close tones more sharply. If your film is properly exposed and developed, the choice of what grade of paper to use for a negative depends on your sense of how that negative should be interpreted.

Photographic printing papers are assigned numbers according to the contrast a particular paper will make from a given negative. The rule is: **The higher the number, the more contrast the paper will have.** These numbers run from 0 for the very low contrast papers to 5 for extremely high contrast papers. Photographic papers are available in two forms, **graded papers** and **variable-contrast** or **polycontrast papers**.

With graded papers, you have to buy a separate supply of paper for every contrast you want. Graded papers are available in a wide range of contrast grades and generally have superior tonal quality.

Variable-contrast papers allow you to change the contrast of each sheet by using a set of numbered filters. Each filter in the set represents a different contrast grade according to its number. The higher the filter's number, the higher the contrast. For obvious reasons, variable-contrast papers tend to be more economical. With practice, it is also possible to use two or even three different filters on the same sheet of variable-contrast paper. You can, for example, use a low-contrast filter (number 1 or 2) to print the sky of a given negative and a high-contrast filter 2 (number 3 or 4) for the

foreground. Variable-contrast papers also have the advantage of allowing you to change the contrast by one-half-grade steps.

Different brands of paper of the same grade will often have different contrasts. This is due to the difference in manufacturing standards and specifications. It is a good idea to become familiar with the characteristics of one brand of paper before trying another.

A **normal** grade of paper (usually grade or filter 2) is one that will make the best print from a negative that has *Normal contrast*. If the negative you are printing has *less* than Normal contrast, you will tend to use a *higher* grade of paper. If your negative has *too much* contrast, you will want to use a *lower* than normal grade of paper. The problem with this random method of printing is that the farther you get from normal-contrast negatives and papers, the more difficult it becomes to control the subtle nuances of tone that make fine prints so beautiful. Ideally, if all your negatives printed well on normal grades of paper, you would be free to use the higher or lower grades for interpreting your images in other, perhaps more creative, ways. Each grade of paper has a unique quality. The secret of fine printing is to discover which grade is best suited to the quality of print you are trying to make, then *adapt the contrast of your negatives to fit that particular grade.* The Zone System is specifically designed to make this possible.

The contrast of a given grade of print is also affected by the paper developer you choose to use. Kodak Dektol is a standard print developer that produces normal-contrast prints when used at dilutions of 1:2 or 1:3. Kodak Selectol-Soft is a slower, "softer-working" developer that will give you less contrast than Dektol on the same grade of paper.

THE CAMERA

Essentially, any camera is simply a device that uses a lens to focus the light being reflected by an object onto a piece of photographic film. It is very important to understand and remember that only a certain amount of this reflected light must be allowed to expose the film. When this is done properly, we say that the film has been given the correct exposure.

The Aperture

The camera has two mechanisms that control the amount of light that is allowed to expose the film. The first is called the *diaphragm*. The diaphragm is simply a metal membrane in front of the film with an adjustable hole in it called the *aperture*. **The larger the aperture, the more light it will let into the camera to expose the film.**

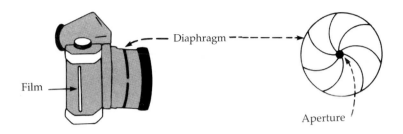

Figure 5: Camera and diaphragm.

The various aperture sizes are measured with numbers called **f/stops**. Typical f/stop numbers are f/1.4, f/2, f/2.8, f/4, f/5.6, and f/8. You must remember two rules relating to f/stops:

1. The larger the f/stop number, the smaller the opening of the aperture. Thus, f/8 represents a smaller aperture (and less exposure) than f/5.6. A simple way to remember this is to consider f/numbers as you would ordinary fractions: 1/16 of a pie is smaller than 1/2 of a pie.
2. The second rule relates to what is called **depth of field**.

When you focus a camera on a given object, any object that is equally distant from the camera will also be in focus. This distance is called the **plane of sharp focus** (Figure 6).

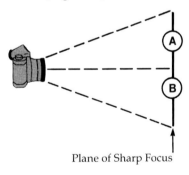

Plane of Sharp Focus

Figure 6: Objects A and B are in focus.

Any object that is within a certain distance in front of or behind this plane will also appear to be in focus. This range of distance within which objects appear to be in focus is called the depth of field. The farther an object is from this *depth of field*, the more out of focus it will be.

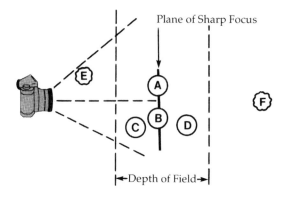

Figure 7: Objects C and D are in focus. Objects E and F are out of focus.

The amount of depth of field depends on the size of the aperture. **The smaller the aperture, the greater the depth of field.** Thus, f/8 will give you more depth of field than f/5.6.

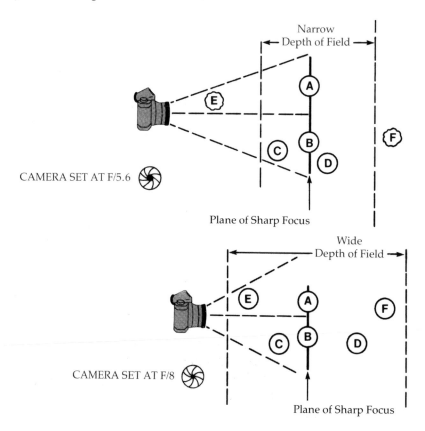

Figure 8: Depth of field increases from f/5.6 to f/8.

This is important to know because there are times when you will want as much depth of field as possible and others when you will want to use a selective focus to isolate objects in a given scene.

The Shutter

The second mechanism that the camera uses to control the amount of light that exposes the film is called the **shutter**. The shutter is a device that determines **how long** the film is exposed to the light that passes through the aperture. **The longer the shutter is open, the greater the exposure**. The shutter is controlled by setting the shutter speed dial. Typical shutter speeds are 1/60, 1/30, 1/15, and 1/8. These numbers represent fractions of a second. Therefore, 1/60 of a second is less time than 1/30 of a second and is said to be a faster shutter speed. Shutter speeds faster than 1/60 are useful for making objects that are moving appear sharp, and also for helping prevent camera motion from blurring the image. As a rule, you should try to avoid using shutter speeds slower than 1/30 of a second when you are shooting without a tripod.

EXPOSURE

By using the correct combination of f/stop and shutter speed, you can give the film the proper exposure for any photographic subject. See Chapter 5 for more information on this subject.

The correct exposure for a given picture is determined by using a **light meter.** A light meter performs two basic functions. The first is to measure the amount of light that is falling on the subject (this is called incident light) or the light that is being reflected by the subject. The function and uses of various types of light meters are discussed in Chapter 5. For our purposes, the hand-held reflected-light meter is the most useful.

The first step for determining your exposure is to set the meter's ASA dial to the ASA of the film you are using. Carefully read the owner's manual that came with your meter to see how this is done. Next, it is very important that you carefully aim the meter at the subject you are photographing. Ideally the meter should "see" exactly what the film will see when the picture is taken. When the meter is activated, an arrow or needle of some kind will swing to the meter number that represents a measurement of the amount of light being reflected by the subject. The important thing to remember about light meters is that **the higher the number, the greater the amount of light being measured.**

The next step is to use the meter's exposure dial to determine the correct exposure. This is done by turning the movable wheel on the dial until the meter's indicating arrow is matched against the number chosen by the meter. At this point, you will see that the meter is recommending a wide range of f/stop and shutter combinations for you to use.

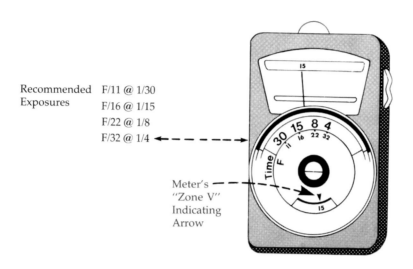

Recommended Exposures
F/11 @ 1/30
F/16 @ 1/15
F/22 @ 1/8
F/32 @ 1/4

Meter's "Zone V" Indicating Arrow

Figure 9: A hand-held light meter and its recommended exposures.

In this example, any of these combinations of f/stop and shutter speed will give you the same exposure. This is true because any given f/stop and **any given shutter speed both allow the same amount of light to enter the camera.** (The one exception to this rule is explained in Appendix H in the section on the reciprocity effect.)

If the meter recommends an exposure of f/11 at 1/30 of a second, f/16 at 1/15 of a second will let the same amount of light into the camera. This may sound confusing, but it will make sense if you think about it for a moment. F/16 is one-half the aperture size of f/11, but 1/15 of a second allows f/11 to stay open for twice as long. This means that the combination of f/stop and shutter speed that you choose should be based on whether depth of field or stopping motion is more important to the picture you want to take. If you want an exposure with greater depth of field, you will choose a combination with a smaller aperture (in other words, a higher f/stop number). If you are photographing moving objects, you should choose an exposure with a faster shutter speed.

Exposure with Hand-Held Light Meters

Let's summarize the general steps for determining an exposure with a hand-held reflected-light meter:
1. Set the film's ASA into the meter.
2. Carefully aim your meter at the scene.
3. Turn the meter's indicating arrow until it matches the number chosen by the meter for that lighting situation.

4. Select a combination of f/stop and shutter speed to use for setting the camera according to the following rules:

 a. If you want great depth of field, choose an exposure with a small aperture (a high f/stop number).

 b. If you are shooting moving objects or hand-holding the camera, choose an exposure with a fast shutter speed.

5. Set your camera to the exposure you have chosen and shoot the picture.

Exposure with Built-In Light Meters

In-camera meters base their exposures on the light that enters through the lens of the camera. This is an advantage in many ways, but a disadvantage in others. Because the meter is measuring the same image you see through the viewfinder, it is very easy to aim the meter properly to include exactly what you want it to see. Built-in meters are also very light, and when combined with modern automatic cameras, they are easy to use.

There are many different types of in-camera meters. For this reason, it is very important that you know which features will best suit your needs before you buy a particular camera. See page 81 for a more detailed discussion on this subject.

Fully Automatic Cameras

This type of camera automatically chooses a combination of f/stop and shutter speed to expose a given scene. Often there is no way for the photographer to know what the actual exposure is. While being easy to use, this makes it impossible for you to exercise any creative control over the photographic process.

Semi-Automatic Cameras

There are two general types of semi-automatic cameras, aperture preferred and shutter preferred. Cameras with aperture priority allow you to choose the f/stop you prefer for a given scene while the meter chooses the shutter speed. Usually the shutter speed is displayed in the view finder so that you can determine whether it is fast enough to stop any motion that may be in your picture. Shutter-priority meters automatically select an aperture for every shutter speed you choose.

One general problem with both semi- and fully automatic cameras is that whichever method the meter uses, you are still locked into using the exposure chosen by the camera. In many cases, this exposure will be adequate, but it prevents you from being able to adapt the exposure to suit your own interpretations. In general, as you become more involved with the process of taking better photographs, you will find that any system that limits your choices will be less desirable.

Needless to say, there is a great deal to be said about the process of exposing your film correctly. At this point, you are ready to begin Chapter 1 of this book.

A Brief Glossary of Zone System Terminology

Acutance The term used to describe the degree to which a negative renders a sharp distinction between adjacent print tones. Acutance is related to negative contrast and should not be confused with image sharpness or resolution. Dilute developers and long development times will increase acutance.

Bracketing After using a light meter to determine the "correct" f/stop and shutter speed for a given photograph, you would use bracketing to give the film more or less than this base exposure to achieve the desired result. Bracketing is usually done by adjusting the aperture.

Contraction The decrease in negative contrast brought about by using a development time that is less than Normal Development. Contraction is symbolized by N-, followed by the number of zones by which you want to decrease the contrast. For example, N-2 means decrease the development time below Normal Development enough to reduce a Zone IX negative density to a density equivalent to Zone VII. Contraction is also known as "compaction."

Contrast
1. Subject contrast refers to the relative difference between the amount of light being reflected by the "highlights," or bright areas, of the subject and the "shadows," or darker areas. This difference is measured with a reflected-light meter.
2. Negative contrast refers to the relative difference between the "shadow," or thinner, areas of the negative and the "highlight," or more dense, areas.
3. Print contrast (also called tonal separation) is the ability of the film and printing paper to render a visual distinction between close tonal values. Print contrast increases when a negative is printed on higher grades of paper.

Density Density is technically a scientific term used to indicate the relative opacity of a negative as measured with a densitometer. The term is commonly understood to mean the relative thickness of silver in the negative.

Expansion The increase in negative density brought about by developing the negative longer than Normal Development. Expansions are symbolized by N +, followed by the number of zones by which you want to increase the contrast. For example, N + 2 means to increase the negative's development time above Normal Development enough to raise a Zone VI negative density to a Zone VIII density.

Fall The term used to indicate the position of any subject's meter reading on the Zone Scale after another meter reading has been placed on a different zone. For example, when the contrast of the subject is Normal, the meter reading for the highlight will fall on Zone VII when the meter reading for the shadow is placed on Zone III.

Important Highlight The area of the subject that you want to appear in the final print as a fully textured and detailed light gray tone. In most cases, this area will be previsualized as Zone VII. Light clothing, concrete, and fully textured white objects are typical Important Highlight Area subjects.

Important Shadow The area of the scene that you want to appear in the final print as a fully detailed dark value. This need not be an actual shadow. In most cases, the Important Shadow Area is previsualized as Zone III. Dark clothing, brown hair, and green foliage are common Important Shadow Area subjects.

Incident Light The light that falls on the subject from the light source; measured with an incident-light meter.

Indicating Arrow The arrow or pointer on a hand-held light meter that is matched with the indicated meter reading to calculate the meter's recommended exposure. The meter number indicated by this arrow is automatically placed on Zone V.

Neutral Gray Card A middle gray (18 percent) card designed for calibrating exposure meters and to serve as a visual reference for color reproduction. Also known as a Zone V card.

Normal

a. **Subject contrast** is said to be Normal when the meter readings of the Important Shadow and the Important Highlight fall on Zone III and Zone VII, respectively.

b. **Negative contrast** is considered Normal when the negative prints well on a Normal grade of paper, usually paper grade 2 or variable-contrast filter 2.

c. **Normal Development** is the amount of development for a given film and developer that will produce contrast in the negative that is equal to the contrast of the subject. Normal Development is symbolized by N.

Placement The act of relating any single meter reading to a zone on the Zone Scale through controlled exposure. For example, to place a shadow reading on Zone III, you first meter that area with a reflected-light meter, then stop down two stops from the meter's recommended exposure.

Previsualization (also *visualization*) The act of mentally picturing a photographic subject in terms of the finished print.

Reflected light The light that is reflected from the scene to the camera and meter; measured with a reflected-light meter.

Resolution The term used to describe a film's ability to record fine detail. Good resolution is a function of sharp focus, fine grain, good contrast, and minimum exposure and development.

Textural scale The range of five textured zones from Zone III to Zone VII.

Tonal range The difference between the whitest white and the blackest black in a photographic print.

Tonal separation See "Print contrast."under the "Contrast" heading.

Tone The shades of gray, black, and white in a photographic print.

Value The light and dark areas of a photographic subject, negative, or print.

Visualization See "Previsualization."

Zone The basic unit of photographic previsualization and contrast measurement.

a. Any one of ten symbolic tones arranged in order from black to white. This ten-step scale is called the Zone Scale. Each zone represents a small range of tones that can be found in both the final print and the original scene.

b. A unit of photographic measurement equivalent to all other photographic controls according to a ratio of 2 to 1.